Casting Shadows Images from a New South Africa | Photographs by **Edward West**

The University of Michigan Museum of Art

This book is dedicated to C.C. and H.B. who taught me the meaning of life.

Casting Shadows Images from a New South Africa | Photographs by **Edward West**

Published in the United States
on the occasion of the exhibition held at
the University of Michigan Museum of Art
2 December 2000–28 January 2001

Director: James Christen Steward
Assistant Director of Exhibitions:
Carole M. McNamara
525 South State Street
Ann Arbor, Michigan
48109-1354

Distributed by
University of Washington Press
P.O. Box 50096
Seattle, Washington 98145-5096

Library of Congress Catalog Card Number:
00-110590

ISBN 0-295-98117-2 (cloth)
ISBN 0-295-98118-0 (paper)

Copyright ©2001 Edward West

Essays by:
Leslie King-Hammond
Mongane Wally Serote
Lemuel Johnson
With excerpts by Athol Fugard

Publication Credits:

Editor: Leslie King-Hammond
Design: Franc Nunoo-Quarcoo and
Maria Phillips, Nunoo-Quarcoo Design
Digital Imaging and Giclee Exhibition
Prints: Graphiti Imaging, St. Clair
Shores, Michigan
Color and Printing: Printed in the
United States by Schmitz Press,
Sparks, Maryland.
Bindery: Advantage Bookbinding
Paper: SAPPI Fine Paper,
Strobe 120 lb. dull cover and
Strobe Silk 100 lb. Text.
Typeface: Monotype Grotesque
Web Site Design: Lutz West,
Seattle, Washington

JOHNSON CONTROLS | **sappi**

Contents

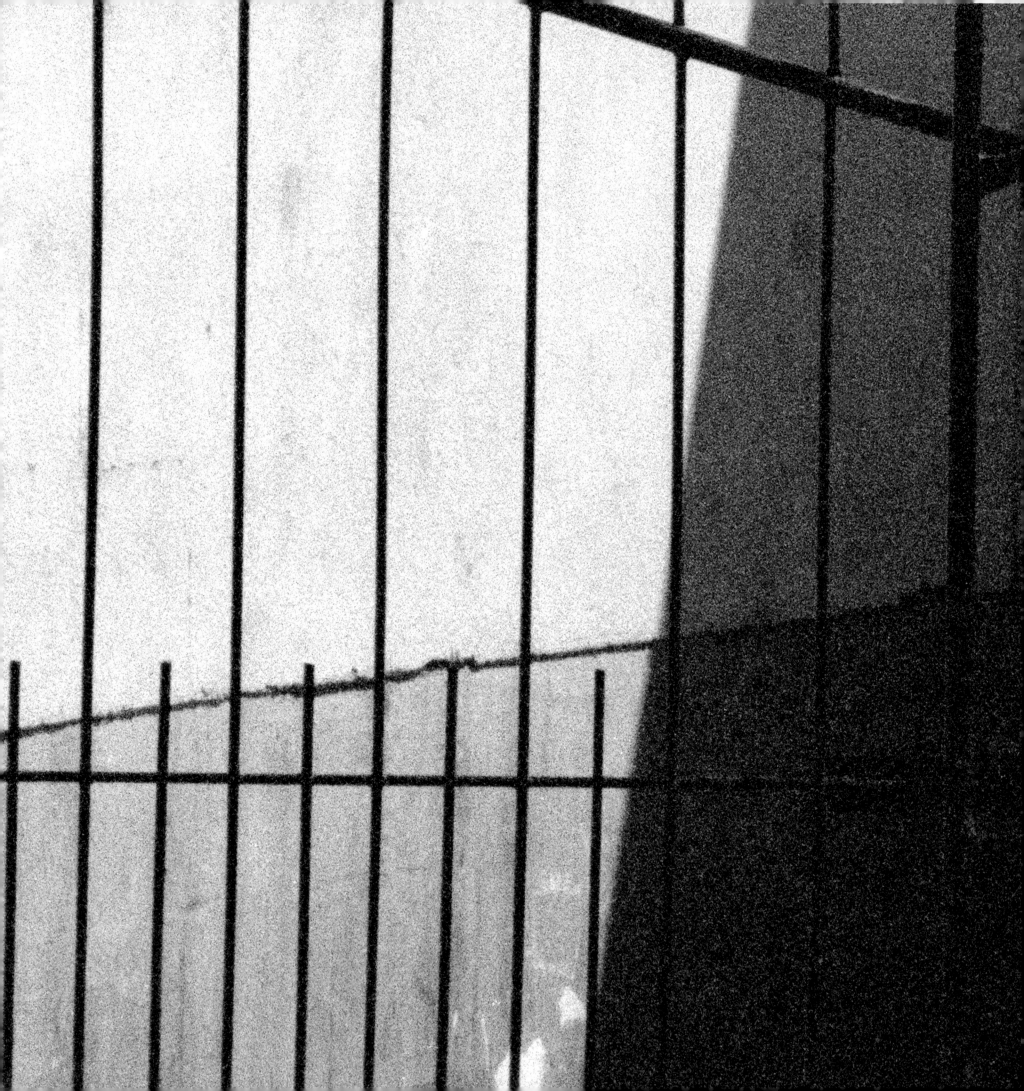

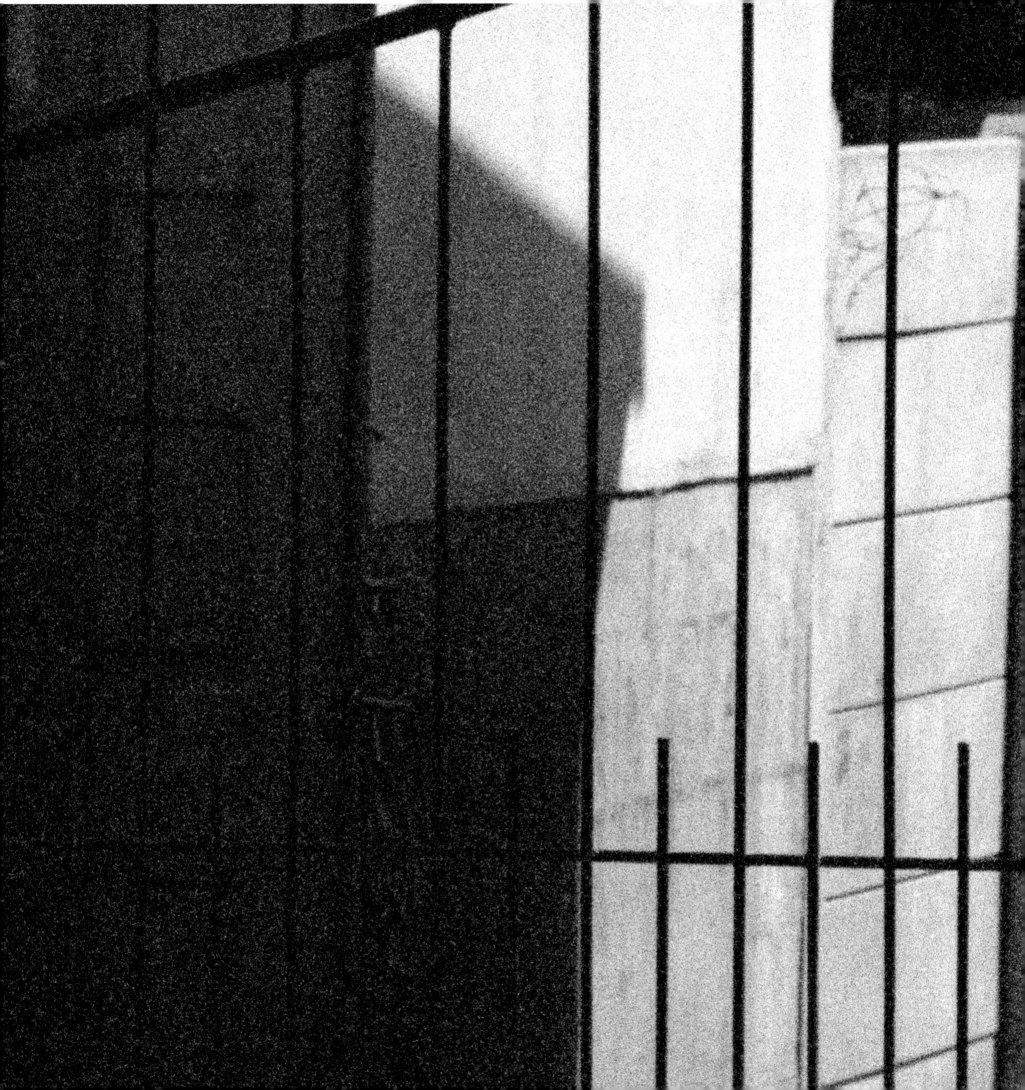

Acknowledgments

The artist gratefully acknowledges the contribution to this project made by Lester Monts, Glyn Grand, Charles and Christella Moody, Linda Gregerson, Chacona Johnson, Carol Small-Kaplan, Jeanine Zaengle, Leslie King-Hammond, Franc Nunoo-Quarcoo, Maria Phillips, Deborah Willis, Sinfree Makoni, Joan McGilvray, Antony Gleaton, Mike Rahfaldt, and my family Catherine, Hannah, Patricia, and Lutz.

With special gratitude for my friends and colleagues in South Africa who made me welcome and showed me the way: Zwelethu Mthethwa, Willie and Eveyln Bester, Peter Magubane, Berni Searle, Russell Jones, Bongani Ngumbela, Steve and Terry Berkowitz, Indaba Ngumbela, Louise Lepan, Antoinette Cloete, Clayton Lillienfeldt, Tessa Gordon, Thenjiwe Kona; Estelle Jacobs, Janet Pillai, Diana Wall, Ofeibia Acton-Quist, and Marilyn Martin.

This publication and related exhibition and events were made possible, in part, through the generous support of Johnson Controls Inc.; SAPPI Fine Paper; Ernestine and Herbert S. Ruben; David L. Chambers and John G. Crane; the Friends of the Museum of Art; and the following University of Michigan Ann Arbor units: Office of the President, Office of the Provost, Office of the Associate Provost for Academic Affairs, Office of the Vice President for Research, MFA Program in Creative Writing, Department of English Language and Literature, Arts of Citizenship, Office of the Dean, Horace H. Rackham School of Graduate Studies, School of Art & Design, Center for Afroamerican and African Studies, South Africa Initiatives Office and the International Institute.

James Christen Steward
Director
University of Michigan
Museum of Art

Foreword

The University of Michigan Museum of Art has made a particular commitment in recent times both to contemporary art and to art that is engaged in the larger debate surrounding cultural meaning. We were, therefore, particularly proud to be a partner in the American debut of *Casting Shadows: Images from a New South Africa* because the artist's work is both visually compelling on its own terms while at the same time engaged with and reflecting some of the most powerful social issues of modern times.

In engaging the complexities of race and identity in contemporary South Africa, in drawing attention to the inequities of class, race and power both in South Africa—and by implication—universally, the artist has created a body of work that is vital to our humanity. And he has done so with a unique visual vocabulary. Utilizing the medium of photography in large scale color Giclee prints, Ed has developed a rich visual language built on the shadow metaphor that at once moves us and grounds us.

When Ed first proposed his work to us, we leapt at the opportunity to show work that made such striking use of color and composition to illuminate the life of the "shadowed" people of South Africa. However, our initial commitment was based on the power of small scale color images, a power that is only amplified in the large exhibition prints that ultimately resulted from the artist's ongoing process. Nor did we fully anticipate the vital connections that would be made in other areas of creative discovery including the eventual involvement of writers of the stature of Wally Serote and Athol Fugard. This sort of connective tissue is at the heart of the Museum we seek to be—a true center for creative exploration grounded in the visual arts but moving beyond it to engage with issues that matter to all our lives. We are most grateful to the artist for this opportunity and to the many donors who have made this exhibition and publication possible.

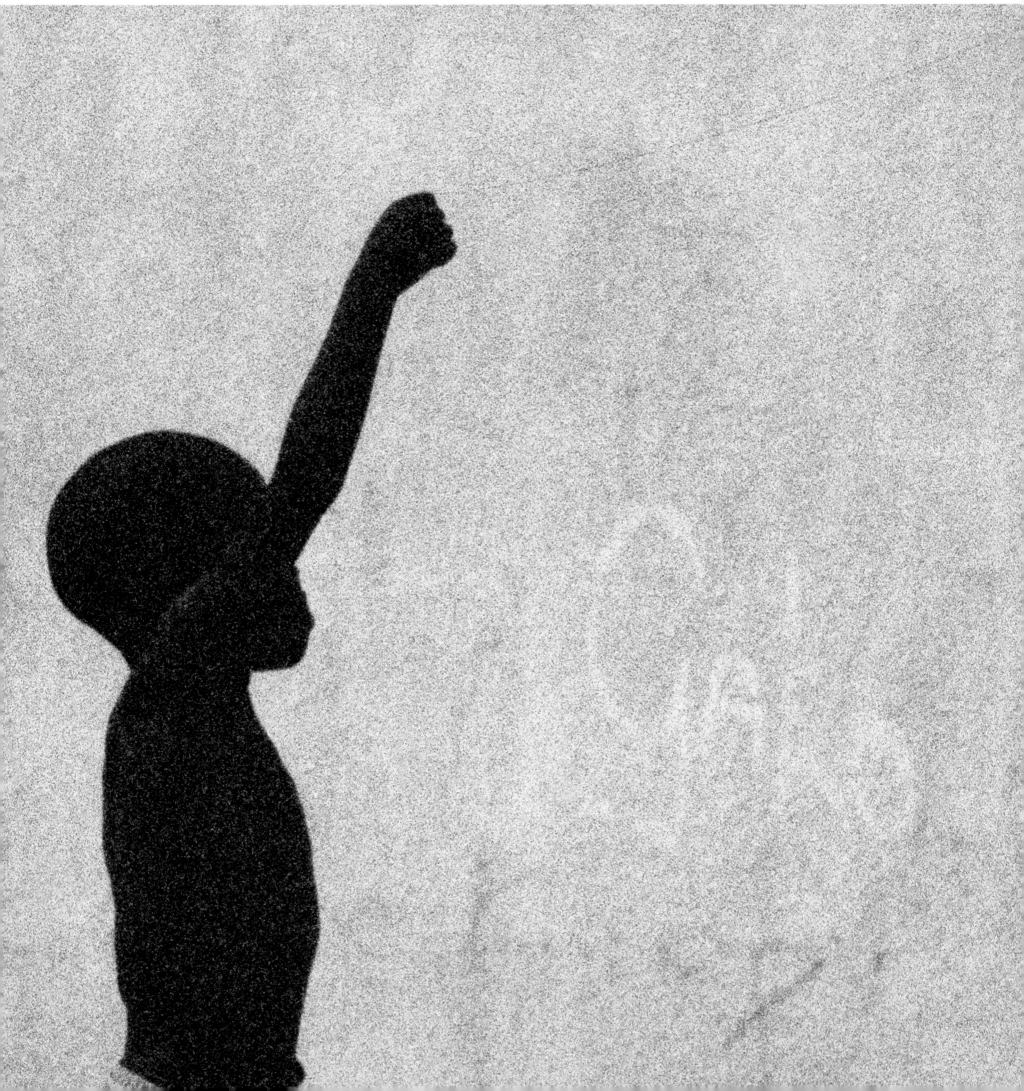

Leslie King-Hammond, Ph.D.

Out of the Shadows/ Into the Light: The Art and Photography of Edward West

"For the first time, the viewer becomes a participant, asked to contextualize his or her own experiences within the visual referents offered by the photographer and in doing so to find her or his own historical perspective, interpretation, or meaning in the works."
Deborah Willis, *Reflections in Black*[1]

The artistry and photography of Edward West emerges at a point in contemporary historical time that is witness to the recognition of the Black photographer as a new member of the mainstream art world. Artist and scholar Deborah Willis, recently awarded the MacArthur Foundation "Genius" Award for her pioneering research on the history of the Black photographer, affirms in her already seminal work *Reflections in Black: A History of Black Photographers, 1840-Present* the poignant and critical contributions of this genre and its image-makers. Edward West is crucial to this growing landscape of photographers who seek to make their personal voice heard and seen through the images they create and craft with the technology of their cameras and the artistry of their intellect and eye.

West began as a self-taught artist and evolved over several decades to become a masterful and professionally trained image-maker of black and white, and currently large scale color photographs that invite and entice. Willis states, "the viewer becomes a participant." Early in West's life he found the need to identify "alternatives" while growing up in the Astoria-Hollis, Queens communities of New York City in order to manage and negotiate his life growing up as a biracial child. Photography became a means to navigate and deconstruct the harsh realities and isolation he all too often suffered as a young man of African decent in America.

It is not surprising that the shadow as a formal element would become a strategic means for West to integrate and identify alternatives and "other worlds" to challenge and feed his intellectual and artistic personality. Early in his formative years while growing up in Astoria he was privileged to have an African American father who was a professionally trained architect. However, America found no positions for his father to fill in that capacity, but that did not stop him from expressing his creativity. Their home was filled with paintings and sculptures done by Edward West Sr. as illustrated in the snapshots and photographs. Young West would watch his father make repairs and modifications to the homes in which the family lived. Given that the West Sr. was an architect the home was always well appointed and cared for much better than the fine art works executed by his father which have been lost to time, history and the absence of any opportunity for these works to have been exhibited or preserved.

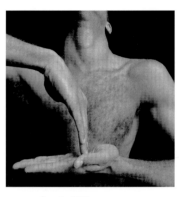

Poonie, 1985

Maxwell Street, 1973. Used on cover for *The Black Photographer's Annual*

Exhibition announcement *The Black Show* Sisson Gallery, Dearborn, Michigan, 1992

In a review of Willis' traveling exhibition of the same title in which West's photographic imagery is included, critic Vicki Goldenberg noted that the history of the Black photographer, "is a history with a provocative notion at its core: that at various times, but especially in the first decades of the 20th century, American Blacks used photography to resist the image the dominant culture imposed on them".[2] Paradoxically Edward West's work has been focused, in recent years from 1996–2000, on the role that the shadow plays in the protection of the identity of an individual, especially as it plays out that function in South Africa. Photo I.D. cards were used as part of a violent system to control Black South Africans. Therefore, the photographic portrait of an individual exposes and thus targets the South African Black's humanity and thus, creates the real potential for a horrid reality of abuse, subjection, imprisonment and even death. West's photographs explore that dichotomy.

Edward West's use of shadow as a way to explore the shifting visibility and invisibility of people of color is grounded in the significant history and theory regarding the role of shadow-like experience in the lives of African Americans and people of the African Diaspora. In the writings of W.E.B. Du Bois' *Souls of Black Folks*[3] the dualistic theories of "double consciousness" and the "seeing" of the black-self as, "perceived by whites through the veil" have been pervasive throughout American and African American literary theory and thought since at least 1903. Ralph Ellison in 1952 wrote the novel *Invisible Man* which received the National Book Award in 1953 and tells the story of a young ambitious Black man who discovers that "I am invisible…when they approach me they see only my surrounding, themselves, or figments of their imagination, indeed, everything and anything except me."[4] The very concept of seeing Black humanity as perceived through shadows, veils and the complex layers of invisibility gives critical resonance to the work of Edward West. West tries to reveal from in-between the cracks of life, the ways and means of how to see people within the African Diasporic tradition of social and political subjection.

It is challenging for the viewer to discern the feeling and the intent of the individuals that West portrays because they are protected by the cast of the shadow. More difficult historically has been discerning the voice of the artist, especially those of African American descent to tell their story, articulate and position their experiences in the Diaspora. This led the writer into a discussion with the artist that attempts the formidable task to illuminate Deborah Willis' research by presenting the authentic voice of The artist in the telling of his own history and evolution that led to the images in his portfolio of *Casting Shadows*. I began by asking Edward West to start at the beginning of his life:

Leslie King-Hammond
Tell me where you were born; where you went to school and where did you grow up?
Edward West
I was born in Astoria, Queens (1949), the second child and first son in an interracial family. When I was born, my parents (Edward and Anita West) were just starting out. So for the first years of my life we lived with my godparents. Then, when I was two we moved out into an apartment of our own in the projects in Astoria.

What was it like growing up in Astoria?
Like most memories from when you're really young, I have clear images of only those things that seemed unusual or important. I remember the church we attended. The architecture was amazing. It was an historic church, and at Christmas they decorated the interior eaves with bound pine trees. For a child living in the projects this church, with its soaring architecture and its grounds with lots of open green space, was really a special place. So was the home of some family friends. They were very left wing. The husband had fought in the Spanish civil war. They lived in an apartment in a large private house with lots of open rooms with tall windows and lots of land around it. This was right next to the projects, so it was unusual. I also joined the Boys Club and that was very important. It offered routine, structure. It was also where I began to swim competitively. Going to these spaces—the boy's club, friends' homes, the church, summer camp—were places where I was able to get away. So, from the time I was very little I knew there were other worlds one could occupy — alternatives to my life.

What else do you remember about your childhood?
When I was nine, we moved to Hollis, Queens. Hollis was then still a German neighborhood. And we were in the first wave of black families to move in there. We moved into a house and the neighborhood was wonderful. In Hollis, when I was a teenager, all the black kids formed social clubs made up of small groups from the neighborhood. We would throw basement parties and go to each of the other group's parties where we would play the latest records of black recording artists. The neighborhood became increasingly black—more segregated than the projects had been.

What high school did you attend?
I attended Andrew Jackson High School in Queens. It was a scary place. On my first day, as I waited outside for the school doors to open, I was almost caught up in a broken bottle fight. The school was huge. There were at least 4,500 students in school built to hold only 2,500. But I was sort-of rescued by two things in high school. One was the swim team and the

other was the Unitarian church. The swim team gave me an identity that was pretty esoteric for a black man (we don't swim you know!). The Unitarian church was also important. One day my father passed by the Hollis Unitarian Church and went in to check it out. It seemed integrated — an interesting mix of people — artists, intellectuals, performers, and political activists. It seemed the type of group that would accept us, an interracial family. So all through high school the Unitarian church was a place where I had my life outside of high school.

What role did the Unitarian church play in your development?
The Unitarian church gave me another world to be a part of. It was small enough and I could have a leadership role. The church gave me a place to become involved with political action. In the church, issues of contemporary political reality were common topics of discussion. The Unitarian church allowed me to be rescued from high school. I wasn't left in the general mix

How did your parents meet?
My parents met during World War II. My mother lived in on a farm outside of Berlin in Hennekendorf. She was the youngest of five sisters. Towards the end of the war, the Russians overran their home. The family fled and was to reassemble in Frankfurt. My mother was the only one who made it. She was 17 years old. She met my father, who was serving in Germany at that time, in a park in Frankfurt where G.I.s congregated. My father spoke some German and served as the translator for his unit of black G.I.s.

How did the German community treat your mother?
She never talked about it or shared much information. Only the littlest pieces came out. It was clear, however, that her family was lost to her. She was isolated and too young to grasp the gravity of her situation. Her family was a typical German family — this union between my mother and my father was unacceptable. After the war ended my mother and father and my sister, who was born in Germany, moved to New York City. Soon after, I was born, and with the birth of my brother four years later, we were three. My mother had only scant contact with her sisters back in Germany. She never wanted to return.

You grew up, in a biracial family, during the 1950's and 1960's. You keep making reference to getting away and having "other worlds." What kind of relationship did you have with your friends or peers?
This was a time when the projects were not racially segregated. It was a post-World War II period and everyone was mixed-up together. It was kid culture that ruled. There was always someone to play with. Always someone to fight with. But there were lots of occasions like when the family would travel to Cincinnati, where my father was born, to see his family that while on the road the reactions to being biracial really kicked-in. People would openly point. It was sort of like that Diane Arbus photograph of the couple with the chimpanzee, that was sort of the sense of it. We were being singled out as an incredible oddity — an aberration. I always knew there were different people but never like that.

What did your father do for a living?
My father was trained as an architect at New York University under the G.I. Bill. But there was no work for a black man as an architect. At heart he was a painter and a sculptor. But for the longest time he was a self-employed sign painter. He painted script on the sides of trucks. His painting style for his own work was Cubist; he didn't get a chance to paint or sculpt much between jobs. His sculpture ranged from realistic, busts, figures, to mask-like treatments. He never exhibited his work. Eventually he became a civil servant, first for the welfare department and then as a probation officer.

Do you have any of his works?
No, they're gone. It's a sad story. My father was an unhappy man, and he didn't produce much, although he was very talented. After my father died, my mother gave most of his artwork away to friends. I don't have any of his work.

And what did your mother do?
My mother was, during my earliest childhood, a homemaker. I remember she made wonderful éclairs and she could sew incredibly well. I have a picture of myself in a suit she cut down from my father that I got for Easter. She was home the first couple of years with us, and then she got a job in a department store, then in a bank. She was a teller, worked her way up to head teller, and then became an instructor for other tellers.

Where did you go to college?
A small liberal arts college outside of Chicago called Lake Forest. I got there because a friend from the Unitarian church was enrolled there and I went for a visit. As you probably remember, there was a desire in the mid sixties for private colleges to integrate — to become less white bastions of power — and I was one of a small group of the talented tenth who was admitted to these private schools populated with prep school kids. So, really, I got in because of affirmative action. College was also where I met my wife, Catherine, on the very first day of school.

Edward and Anita West, Frankfurt, Germany, 1944

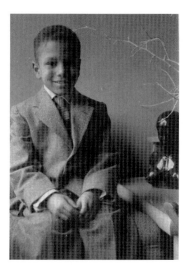

Edward West with one of his father's sculptures, Astoria, New York, 1957

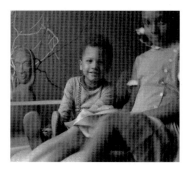

Lutz West and Patricia West with one of their father's sculptures, Astoria, New York, 1957

When did you begin to develop an interest in photography?

When I was in first or second grade, our class took a trip to one of my fellow student's father's photographic studios. I remember being in the space with all the props and equipment and finding the environment fascinating. But I didn't really become actively involved until my senior year in high school. A friend, Joel Charrow, sold me his Minolta camera because he was looking for an upgrade, and I was hooked. After high school, I worked at the New York Central Railroad and made enough money to buy my own upgrade to a Nikkormat. So I went off to college with this camera. In my freshman year, I went to Berlin for a semester. I took my camera with me and I made my first series of photographs. That's when I had my first 'go'; in a German world I thought I was presumably a part of because of my mother. Before, I had been photographing friends. They were, at best, ambitious snapshots. When I was in Berlin, away from everyone, I began to have the pretension of the artist. I was trying to capture, visually, a sense of this new world I was in through the textures in the architecture, the spaces, and the people who inhabited those spaces. Unusual events for me— the first time I had seen an actual chimney sweep, centuries-old rooftops. It was my first non-American experience. And it was the otherness of the physical world and the architecture that struck me—the alleyways, the simplest of objects, the buses, the trains—all those things that I would see and use along my way to school each morning. In Berlin everything I thought I knew had a different form. And it was that fascination with the difference that prompted me to want to photograph it. To capture something that would be difficult to tell but could be shown. There were two events that year that were, in fact, extraordinary. That spring, while I was in Berlin, Martin Luther King was assassinated. The jarring lack of context made me feel out of phase in Europe, away from those who would recognize the true meaning of this event. Only a short time later Europe erupted in student strikes and demonstrations, a struggle I recognized from New York, and I photographed the demonstrations.

What did you do after your trip to Berlin?

I was self-taught in photography. And after Berlin I had three years of study in art history. After graduation from college I applied to graduate school. While I had a degree in art history I didn't want to go on in that area. I realized that I did want to continue in photography and that if I wanted to continue I needed to find some real instruction. So I applied to Rochester Institute of Technology and got into graduate school. New graduate students in the program had a summer-long intensive course to be brought up to speed. It was eight hours a day, five days a week of instruction in all the chemistry, studio,

darkroom, the whole nine yards. Absolutely amazing! All in one summer. That summer was my photo education. I stayed for a year at RIT, graduating from what was meant to be a two-year program. I had had enough of Rochester.

What were some of the highlights of that experience?

During my year of study I and another grad student from the program interned at the Eastman House. Because both of us already had internship experience, the Eastman House provided us access to the different parts of the organization. We restored daguerreotypes, worked in the library, hung shows, did research, and worked with the director, Van Deren Coke, and curators Tom Barrow, Robert Sobieszak, and historian Dennis Longwell. It's safe to say that throughout my entire education, from kindergarten to graduate school, I never had a black teacher.

Spring 1972, Catherine and I decided to move on. In September 1972, we got married mostly to get enough funds together to move to New Mexico where some of our closest college friends had moved. Coincidentally, Van Deren Coke had also announced that he would be leaving the Eastman House to go back to the University of New Mexico, where Beaumont Newhall was teaching the history of photography. When we got to New Mexico I applied for a job at the University.

What did you do to survive in New Mexico?

While I waited to hear from the University, I had a teaching certificate and so I was able to get a job teaching elementary school. The day after accepting that position, I got a part-time job at University of New Mexico teaching photography. So I was teaching sixth grade during the day, and college at night. When I was not teaching, I was doing collage and some daylight strobe work that was figuratively orientated.

You mentioned that you had an internship at the Metropolitan Museum of Art—did you ever have the opportunity to meet Reginald McGhee?

Reggie McGhee was working on the *Harlem on My Mind* exhibition as a researcher and it was then that he rediscovered James VanDerZee. Part of the thing about being at the Met was that I poked my nose into different areas of the museum. That's how I came to know about the Harlem project. I introduced myself to Reggie, who in turn introduced me to Henry Geldzahler, the curator of 20th century art. I found myself at the heart of the art world.

Did you ever get to meet the photographer James VanDerZee while you were working at the Met?

No. But I did meet him through his pictures. That's what seemed important at the time. Just to be aware of this person. His age and importance made me feel that it would be a presumption to ask to meet him. He had already given me something through the images. I did get to meet a community of image-makers that rallied round his name in the James VanDerZee Institute. And I became aware of a history that had not been a part of my formal education where the tradition of black photographers had been invisible to me. The rediscovery of VanDerZee's work was really a revelation for all of us who were black photographers. We worked in isolation and the *Harlem On My Mind* show became that foundation of knowledge of our own tradition.

While at the Met, I did poke my nose into the photo studio where the staff photographer gave me my first lighting lesson, an introduction to view camera, and how to use the slide-rule to calculate bellows extension. The lighting experience I gained there formed the foundation of my desire to get the better technical grounding that would lead me to RIT.

How did you begin to develop contacts with other photographers?

Other than my New York connections like Tony Barboza, when we were in New Mexico someone told me about the "Society for Photographic Education" (SPE) conference to be held at the Ghost Ranch in Abique, New Mexico (home of Georgia O'Keefe). It was at a very important time when photography started to have increased importance in the culture. But the core of true believers was still relatively small, and it seemed everyone was at that conference — virtually a Who's Who of American photography. I think I was the only person of color. Schools at that time had just begun to consider hiring people of color. At breakfast one day during SPE I was sitting with Barbara Crane, who ultimately engineered a job for me at the School of the Art Institute of Chicago. The following fall, Catherine and I moved to Chicago to teach at the then largest fine art photography program in the country.

How and when did you develop an interest in South Africa?

In fall 1973 we moved to Chicago. Several years later, in the fall of 1976, I saw a play by Athol Fugard, *Sizwe Bansi is Dead*. It was set in a photographer's studio in New Brighton Township in South Africa, and it was concerned with the pass laws and the photographer's role in creating identity. Seeing that play was a critical experience. The performance was riveting. It began my education about South Africa and

galvanized a sustained interest in the country. *Sizwe Bansi* was my first experience of intimate theatre — the two-person play. We sat close to the stage. We became part of the event — part of the lives being lived on stage, part of an exchange between people. Local things — all the action was local. I was interested then, and remain interested now, in private communications across distances. — pen pal letters to other countries, collecting stamps — little bits of things which suggested whole worlds as the two-person play suggested the whole of South Africa.

Did you have difficulty traveling to South Africa?

For years, travel to South Africa was legally and morally impossible. I had wanted to travel, but it was far too expensive for me to go without support. Airfare alone was nearly $2,000. At every opportunity, in conversation with people at the University who might fund my travel, I spoke of my desire to go. I watched delegation after delegation go to represent the University, but could not deal myself in. It seemed that no one understood the value that photography could provide. I had argued that as a photographer I could make South Africa knowable. I kept asserting my case until finally, Lester Monts, the University's Provost for Academic Affairs, heard what I was saying. Then at the election in 1994, after I had obtained funding and bought my ticket, I was stopped by an aneurysm, the result of a congenital condition, which ruptured after a strenuous swim. After a series of surgeries and years later, I was finally fit to travel.

What was your philosophical attitude in preparation for this experience?

It was important for me to go with an open mind. I didn't want "to vacation in other people's misery". I also wanted to be there at the time of change. Black people in America frequently link themselves to West Africa because of the slave trade. But my lineage is not singular — my life experience is about a life between cultures. And that's what South Africa represents — a dynamic across cultural lines. Being of mixed race, meant being between — not having the luxury of black over white or white over black. In South Africa, in apartheid's forced removals, the so-called colored community was intentionally used as the buffer between the white and black communities. The hierarchy of color that I experienced as a child, ("If you're black get back") — a racial pecking order based on the shade of your skin — suggested a class structure which was repeated in the class structure of South Africa, that is: white, Indian, colored, black. Like *Sizwe Bansi* where we project ourselves into other identities, I projected myself into South Africa.

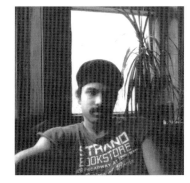

Edward West
Chicago, Illinois, 1978

What had you anticipated as your project or plan action during your visit?

When I went, I assumed I would photograph the so-called colored communities. But life led me to the Eastern Cape, one of the poorest sections of the country, and yet one of the most historically significant. The Eastern Cape is the location of many of Fugard's plays. Mandela and Tutu attended the University of Fort Hare in Alice. Lovedale College there was the first school for blacks in South Africa, and it was also the site of much of the resistance. It's also extremely rural, a place where tribal life is still very present. I came to recognize it, and through that recognition I developed a kinship with the people of the region. I didn't focus on the ceremonial events in which I would be spectator. I photographed people with whom I participated, finding points of contact—empathy not sympathy. My South African images are not dreams the way a drawing might be. They are realities—locations on a larger map. So, going to South Africa after the election, these images are locators on the space/time map of the country's change. They are a particular moment in the transformation.

After you arrived in South Africa what was your reaction to the reality you encountered?

I finally got to go to South Africa with a group from the University of Michigan in 1997. Johannesburg was the first city we encountered, but not the center of town, but an exclusive suburb, Sandton, removed from the inner city's danger and decay. So my first impression was of the fading light and the particular aloneness that you feel in a strange city. The next morning we went to Soweto and there I was struck by being in a world dominated by black people. (that is, a return to the world of my adolescence.) I thought my plan was to go to Cape Town to photograph in the so-called colored community. Again projecting myself into that situation, I had wanted to understand the racial dynamic. Maybe because I knew and understood the projects so well, I didn't focus on the poverty. It wasn't the poverty I saw. I saw people — a community with its own life and logic. I was seeing the daily things not the hype. In the white world, for me, there is isolation. In the black world there's inclusion, life in a world. You're part of something you recognize.

I wanted to come to the country, not to photograph the big events, but to photograph lives lived every day, in part, because my own life had shown me the centrality of the everyday. It's also in the commonplace, in the rituals of the everyday, where there was real personal ease — these were the times when I could look around. In my life we moved around a lot — so we could only take with us what was essential. So for me, meaning was never vested in possessions — it

was about the talismans, the symbolic something. Your identity is in the sense impressions of who you are. If you're moving, your life is caught up in the details of trying to make accommodations to present conditions — to focusing on the bend in the road. In many ways, my own history is lost to me. I never knew either set of grandparents. My mother fled her country bringing little with her. I have few artifacts, no records, only impressions. And these impressions are not about big events. They are about exchanges and telling moments from my childhood. I have the sense impressions of memory. The woman from the projects jumping out a window to her death. Being awakened to gunshots. Faces floating in and out — people who made a difference. Their names, sometimes forgotten, but their influence fundamental.

In the "Casting Shadows" series of photographs, subjects are bathed in soft light and shadows that create a strong sense of anonymity. Is this intentional and why?

Yes. I try to protect the individuals. People assume that if you're taking a picture of someone it means capturing the face so it can be scrutinized. In apartheid South Africa for black people to be seen in that way was a form of jeopardy. If you were photographed at a student riot you could be identified and they would come to your house, drag you out and that would be that. So people, of course, still had concerns about being seen. I was aware of that. That's one of those things that came out in the early experience of seeing *Sizwe Bansi is Dead.* In apartheid South Africa, the picture was always a weapon in the form of the pass. In addition to wanting to protect people's identities, I also believe that the gesture of our bodies is as individual and as telling as our faces. In many ways it's a more direct, more animalistic way of understanding people. The images are all full frame. Taken on the street. The desire to photograph people on the street comes from my childhood. People outside, no air conditioning, people in the streets, kids running everywhere, parents at a distance, that's where the life of the community is lived. The culture of my childhood was street life. Apartments in the project were small and the life of the community was lived on the street— in the projects' green spaces that were the sledding hills and playing fields, the concrete sidewalks that became the Skelsie game boards, the walls that became the handball courts, the streets that were for stickball or games of touch football. During adolescence we moved to the stoops as our social spaces. So my expectation from early childhood through high school was around life on the street. In high school during the 60s, the street was the place for demonstrations. Greenwich Village was the island of escape where chess was played in the park, where all the exoticism of New York's

diverse population paraded. It's the piazza — an arena for new possibilities in your life. My first experience with photography was on the street in Berlin. Here life — youth culture — was still lived on the street. But by then I had a camera.

Your images are filled with rich cultural symbolism and metaphors that excite your artistic intellect. What are some of those specific elements?

Duality is something I have always sought to understand — the prismatic shift between states of existence. My own racial heritage is that form of existence. In this project I'm interested in the duality of visibility and invisibility—how metaphorically the shadow protects identity but historically it also defines black South Africans as shadows of the white population. For example, Soweto is nicknamed the "Shadow City", in part because it lies in the shadow of Johannesburg (geographically removed) and because it's totally black community. There's also a language primer for people learning Afrikaans to teach them to deal with their black servants. In covering orders to use with servants at a golf course, the primer has phrases like "do not rattle the bag", "pick up the ball"; and then "move your shadow." So shadow is demonstrably about that state of being invisible. Now, post apartheid, people of color — always the majority in the country — are becoming more visible. But the shadow still remains — the shadow of past abuses, and also the shadow that obscures the future. Protecting, concealing, obscuring, revealing — the shadow is at once a positive and a negative force— a place of privacy and a consignment to obscurity. I hope that my images protect the individual while speaking for the community as a whole. One of my early lessons while in South Africa came from an Indian who had a long family history of fighting for social justice in South Africa. He explained that in the movement everyone self designated as "black" whether they are black or Indian or so-called colored, because it's more about the collective than the individual. During this period of transition, as people emerge from the shadow, people still need to be protected, to feel safe as individuals while still represented as a collective and rendered as black until the transition is complete.

Why do you use color instead of black and white film?

Color is vital for this project. It is assumed that shadows are black—the absence of color. And yet any artist knows the shadow is defined by its color — made of color. As one reads the news reports about South Africa the "problem" is always stated as black and white. Someone gets killed because they were in the wrong place at the wrong time. As you learn more about the country, as you travel within the country, you begin to see the shading of how tribal differences mix with racial differences and it's no longer black and white. The Xhosa and the Zulu were always pitted against each other, for example, so there was never only a sharp black versus white contrast. The use of color refers to this more complex, more multi hued relationship. Also, within the country color is a powerful personal tool. It is used to distinguish your home and your clothes, or to celebrate events and rites of passage. Color is also one of the few luxuries that people can afford and the bold use of color has always seemed like a confirmation of people's resilience in the face of incredible hardship.

What are your ultimate hopes for your work?

To make something that is invisible, visible. To celebrate communities. To link us through our common cause. To reveal the richness of the everyday — the everyday community — talking, going to market, church, any/all presumed mundane activities. It is there that people find the richness of life in exchanges with their community. Those things that speak to a common humanity, which reveal the dignity in all these lives. It's not about what they lack, but rather, what they have in this moment of redefinition.

What do you envision for your work and future projects?

My next project won't take me as far from home. I have a couple of ideas in mind, but until I do them I really don't ever talk about them. Next projects for me always grow out of the existing ones. Out of necessity it will be concerned with some form of representation that is useful to those represented. In the midst of this project I did another that is emblematic of what I mean. I found myself repeatedly in the Eastern Cape in the town of Alice. My affinity for the people of Alice led to a project in which faces were revealed. Here I made more traditional portraits of the residents. Then I had an exhibit of the photographs and invited the community in to see them. At the end of the show, everyone pictured could come to claim the pictures for themselves. I also made a duplicate set of these photographs and archived them at the University of Fort Hare as part of the ANC archive currently housed there. The goal here was to reveal, not conceal individual identity. These became the family pictures the community needed/wanted. In the next project too, I want to use my skills in collaboration with others. The important thing is that the work goes on, that people participate, and that things get done.[5]

The photography and artistic life of Edward West is now moving into his mature mid-career life. His early experiences have given West a means and the skills to now address some of his greatest challenges to come. It is however in the nurturing humanity, and integrity of his family combined with the courageous strength and pride of the South African people and the experiences he had in that country that will guide and inform West in the future. In reflecting about his travels and encounters West relates that, "if you remove the journalistic moment of confrontation, violence or death, then what you meet there are the communities of people with a positive drive in life even if they are in poverty. In fact, they are incredibly generous despite circumstances that might suggest otherwise."[6] It will be in that same spirit of generosity that Edward West embarks on this next and most challenging phase of his photographic artistry and philosophic meditations on coming out of the shadow into the light.

Endnotes

1. Deborah Willis. *Reflections In Black —A History of Black Photographers, 1840-Present.* New York: W.W. Norton & Company, Inc., 2000, p. 171.
2. Vicki Goldenberg. "When Asserting a Self-Image is Self-Defense" *The New York Times,* Sunday, April 9, 2000, Section AR, p. 39.
3. W.E.B. DuBois. *The Souls of Black Folks.* New York: Bantam Books, 1989 (1903), p.3
4. Ralph Ellison. *Invisible Man.* New York: Vintage Books Edition, 1972 (1952) p. 3
5. This interview occurred on October 6, 2000 with numerous conversations which took place September 8–November 9, 2000.
6. John Woodford. "Street-Shooting Man–Photographer Edward West" *Michigan Today.* (The University of Michigan, Ann Arbor), Spring 1999, Vol. 31, No. 1, p. 11.

Leslie King-Hammond

Leslie King-Hammond, Ph.D., Dean of
Graduate Studies at Maryland Institute,
College of Art, was Project Director for
the Ford Foundation-Philip Morris
Fellowships for Artists of Color Working in
the Visual Arts, initiated by the Maryland
Institute in 1985, an effort to increase the
participation of minorities in arts leader-
ship. King-Hammond is active in the
civic and professional arts community,
serving as president of the College Art
Association (1996–1998), on the Board of
Overseers of the Baltimore School for the
Arts (1996–present), and on the Advisory
Board of the Edna Manley School for
Visual Arts in Kingston, Jamaica
(1988–present). She has published widely
in journals and exhibition catalogs, most
recently in *Joyce J. Scott: Kickin' It with
the Old Masters* (The Maryland Institute,
College of Art and The Baltimore Museum
of Art, 2000), *Gumbo Ya Ya: An Anthology
of Contemporary African American Women
Artists* (Midmarch Press, 1995), *Three
Generations of African American Women
Artists: A Study in Paradox* (catalog and
two-year traveling exhibition, 1996–1998),
essayist and vice president for the *Jacob
Lawrence Catalogue Raisonné Project*
(2000), and *Masks and Mirrors: African
American Art (1750– Now)* (forthcoming
from Abbeville Press).

Mongane Wally Serote

Images: Opportunities and Tribulations

The strength of photography lies in its ability to freeze images for eternity. Because of this power, our ability as human beings to manipulate the techniques of photographing must be continuously subjected to discipline, courage, responsibility, honesty, and informed creativity.

We are richer in terms of all of the visual arts because of the honesty and creativity of the Khoe and San, our ancestors, who handed over to the twenty-first century experience the first images made by the human hand, now fixed for eternity on the rock walls of their landscape.

It has been a revolution for humanity to leap from rock painting to photography to motion photography to the information highway. Yet even within this cultural boom and bloom is the confirmation that history will always repeat itself. And within these repetitions lie the fortunes and tribulations of the human race.

Once, the image was frozen on rocks. Now, it can race to all corners of the world within seconds. Once the image used the simplest means to express profound ideas. Now it has become sophisticated in both its means of creativity and in the manner it articulates ideas.

Yet, constant despite all of these leaps and bounds must be basic honesty and responsibility. The purpose of the image must be, as it was then, to record, to inform, to touch both the mind and emotions of the human race. And to communicate all this so that humans can better seize the opportunities and fortunes that are inherent in history's repetitions. Only then can we become better and the world livable.

These thoughts about history and culture form the context for Edward West's images of one of the most despicable dramas of the human experience—the impact of the apartheid system on black South Africans.

West uses color to intensify the impact of what he sees. He transverses the urban and rural areas, framing houses, walls, graffiti, doors, windows, barbed wire—all of the things that fence in humans. Yet also all of the things that comfort them, that give them space, place and a sense of the moment—that create people's environments and who they are. Shadows soften all of these things. And then, out of the shadow, the child, the man the woman is illuminated—bare, seated, standing, walking, doing chores, gesturing.

By 21st century standards something is wrong in this place where there is such intense dark and light. South Africa produced the prime evil of Eugine de Kok; it also produced the courage of Steve Biko (and his fate); South Africa produced the torture of the "necklace", but it also gave us the young people who resisted apartheid (the "lost generation"). Most recently the country produced the "Truth and Reconciliation Commission", an attempt by South Africans to resolve this unfinished business in the human experience.

It is this unfinished business that West freezes for all of us to witness as we enter the new century. First it was the slave trade, then colonialism, then the holocaust, and then the apartheid system. All of these policies keep saying, on the one hand, that there is something wrong with human beings. On the other hand, they keep saying categorically that a deep-seated trauma has been placed upon generation after generation.

We, as humans, seem unable to seize the fortunes and opportunities given to us by history. Instead, capitalists fight communists; communists fight capitalists. The power hungry escalate the creation of weapons of destruction and educate new generations to perfect systems of subjugation—as if the intrinsic and inherent abhorrence for oppression by human beings can be destroyed!

And this is why images must be the result of objectivity, honesty, courage and responsibility. Because they are a mirror—not of Africans or Blacks or the poor—No! They are a mirror of generations of the human experience.

West, like many before him, has belled the cat. And, at the press of a button, his message is able to fly through space in all directions. If the 21st century signals the reality of the global village, this swift presence of images in our lives is most relevant and appropriate.

The thing is, the unfinished business of history will also be part of that swiftness and presence. West's images of the unsettled legacy of apartheid reawaken the issue of slavery, reminding us that that terrible human venture is unresolved.

Let all human beings know that for as a long as there is silence about that devastation, it is for that long that all Africans, all black people, all non-whites will feel afflicted, discriminated against, and intuitively suspicious that someone somewhere is preparing the boats, the ships, the shackles, and the slave lodges and castles.

Some people in South Africa have called almost desperately for South Africans to unite, to take firm positions for non-racialism, non-sexism and democracy. Not so long ago people who held these positions were hunted down. And the evidence is there in the hundreds of graves scattered all over the Southern Sub-region of Africa containing these people's comrades. We must, all of us, examine our lives against that backdrop.

As globalization increases, we must not allow history to repeat itself in a way that allows people to perish through poverty, ignorance, illiteracy, disease and total marginalization to the point that only as prostitutes, pimps, thieves, drug peddlers, or beggars can their children eke out a living.

I think it is this awareness that prompted West to make a decision to use his skills as a photographer to explore the unresolved history of my country. I think these photographs offer us a moment to reflect and to examine our lives so that we can equip ourselves to engage the tribulations that are part of the repetitions of history. Only then can we seize its fortunes and opportunities. I think West has used his skills to point to and give voice to a people with a terrible past, who are learning to live, now, in an unsettled present.

Mongane Wally Serote

Called by Nadine Gordimer "The most important poet of his generation", Mongane Wally Serote is a writer, novelist, poet, and cultural critic. Recognized for such works as *To Every Birth It's Blood,* (1981), *A Tough Tale* (1987), *On the Horizon, Essays* (1990), *Third World Express* (1993), and most recently *The Hyenas* (2000) a collection of essays. Serote is currently a member of parliament and Chair of the South African government's Portfolio Committee on Arts, Culture, Language, Science and Technology.

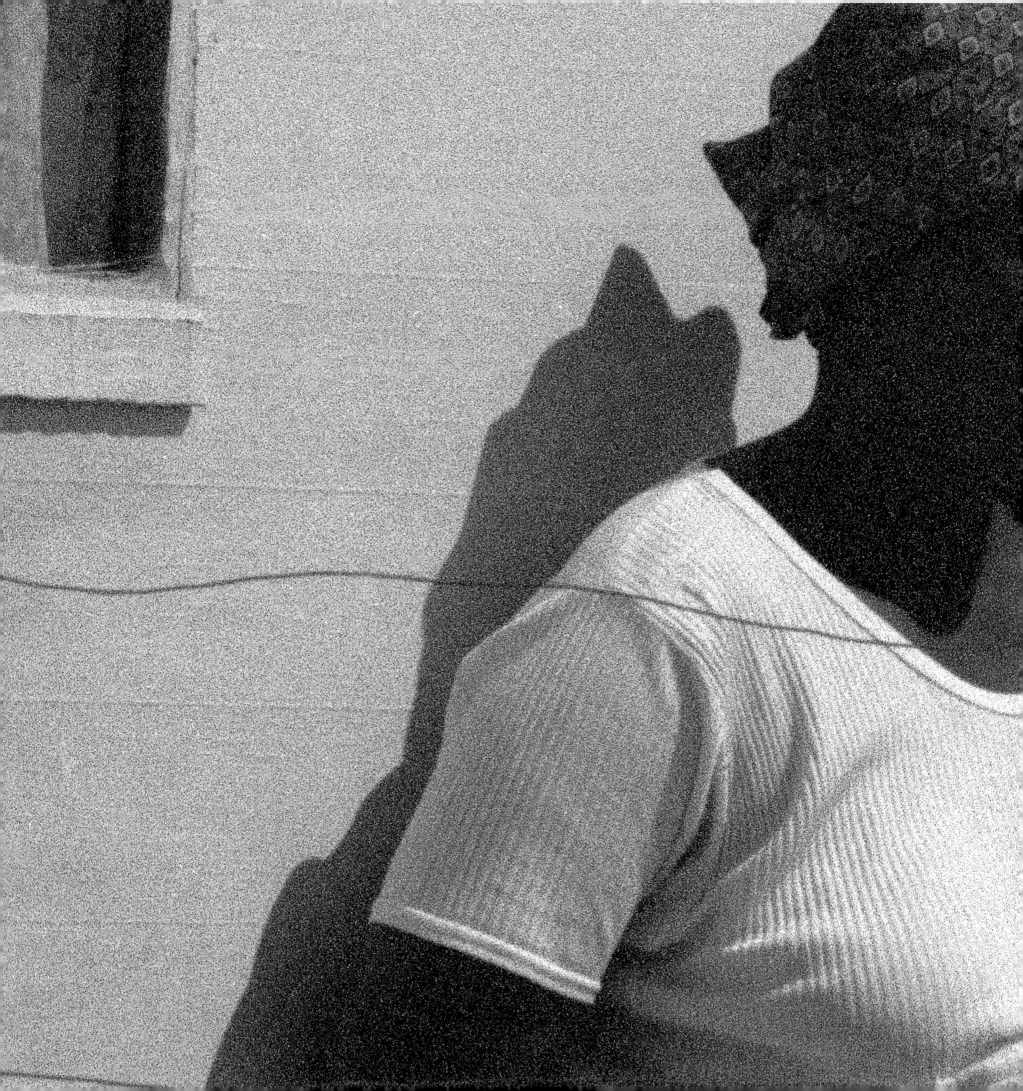

Lemuel A. Johnson, Ph.D.

The Shadow of a Truthful Lie

A man went down to the river
to fetch water with a basket
and returned home with none.
Atukwei Okai, "Taflatse"

Some two years ago, the American television program *60 Minutes,* on CBS, devoted a segment to the new Republic of South Africa and the proceedings of its "Truth and Reconciliation" Commission. I recall experiencing the broadcast as a sequence of highlights which produced variously shocking but nearly always misaligned intensities. On one such occasion, the testimony of witnesses was enough to send Archbishop Desmond Tutu head down and in tears at the head table. On another, during a radio call-in program this time, Tutu invited white South Africans to come forward and be forgiven. It was an invitation that provoked a range of responses, among them that of a caller who was, in fact, not at all interested in being forgiven by anyone and who objected to the exercise as a waste of time.

Exchanges like this one provoked a disbelief that made it hard not to recall the now severe, now comical irony in an early short story of Isaac Bashevis Singer, titled "The Slaughterer." Cues that man has no business, really, being more compassionate than God haunt this story about "light in the higher spheres" and pits full of slaughtered animals. (1996:207-216).

As I looked on, and indeed well afterwards, I remember thinking that I was watching something that had been scripted—but badly botched—from a 1930s poem by the great Afro-Cuban poet Nicolas Guillen. Titled "Balada de los dos abuelos," the poem famously begins with the lines: "Sombras que solo yo veo, / me escoltan mis dos abuelos.../ mi abuelo negro..../ mi abuelo blanco."

Shadows which only I see:
I'm watched by my two grandfathers....
my black grandfather...
my white grandfather...

This is a poem in which the shadow images of the two grandfathers emerge with photographic clarity, the result of a set of images that include "bone-point lance" and "gray armament"; so too "drum of hide and wood" and "ruff on a broad neck." Soon enough, however, the purely visual reaches outside itself to become articulate with moral anxiety. Speech that visual imagery can no longer silence intrudes; and what it expresses is something that the images could hardly have intended to silence in the first place: "I'm tired....I'm dying....I'm tired" (69)

This fixing of shadows also occupies Athol Fugard, John Kani, and Winston Ntshoma in the South Africa of their *Sizwe Bansi is Dead.* "When you look at this, what do you see?" They ask because when the camera clicks in the character Styles' Photographic Studio in the African township of New Brighton, Port Elizabeth, the occasion is always more than a matter of "'No expression, please'...click-click....'Come back tomorrow, please.'" The studio and its display board are, in reality, entry points into a "strong-room of dreams." And "This was our Grandfather" is typical of the exhibits that we encounter there which capture the past in the present of the photographic image. If it weren't for the likes of Styles, *Sizwe Bansi is Dead* insists, "children's children" would not remember the "story of people the writers of the big books forget about" (1986:12-13).

This threat of erasure mirrors what the narrator in Mongane Serote's *To Every Birth Its Blood* is driven to consider on the streets of the township of Alexandra: 'So, time, like a river, can take us away / can erase our flesh?'" (1989:46).

So, too, Guillen reminds us of the power of affiliation ("Shadows which only I see: / I'm watched by my two grandfathers") just before the poem heads into its finale. There, the pictures at an exhibition face the burden of reconciling, or of being reconciled to, the problem-filled transformation of memory and the present into past history and violent excess.

Sizwe Bansi is Dead, meanwhile, gives us another relevant insight by informing us that the photography studio is next door to the township's funeral parlor, and accentuating this fact with the counterpoint in knocks that this proximity produces: "When I hear...*[knocks solemnly on the table]*...I don't even bother to look up, man. "Funeral parlour is next door." But when I hear...*[energetic rap on the table...]*...that's my sound, and I shout 'Come in!'" (13).

Faced with such a temptation of roots—and a conflict in routes —Guillen's "Ballad of the Two Grandfathers" opts for truth and reconciliation. But Nicolas Guillen's Poet/Photographer/ Witness is luckier than the Archbishop-Confessor we encounter on *60 Minutes*. The former can conjure up and celebrate a bringing together of "Black longing" (Facundo) and "white longing" (Federico). The two men are re-figured and made equal "beneath the high stars," where they "dream, weep, sing. / They weep, sing. / Sing!" the ballad to conclusion.

"Have you got all my particulars?"

"Did Friday ever grow enamored of you?"
"How are we ever to know what goes on in the heart of Friday?... We have lived too close for love....Friday has grown to be my shadow. Do our shadows love us, for all that they are never parted from us?"
 J. M. Coetzee, Foe

Significantly, it is again Nicolas Guillen, now somewhat uncertain about how truth and reconciliation can be processed as historical truth, who raises the question about "particulars." He does so in "My Last Name" ('El Apellido'), a poem that was written nearly half a century after "Ballad" apparently reconciled the dilemma of being shadowed and shadow, of being photography studio and funeral parlor. "Well, then, I ask you," "My Last Name" now insists, "How do you say Andres in Congolese, [and] / In Mandingo how do you say Amble?" Questions like these come because our poet, our Witness-as-Artist, is now determined to worry the boundaries between shadowy essence and named substance.

In Guillen's "My Last Name," identity dislocations arise despite, or indeed because of, a "password" - a named substance. But what if certain kinds of "particulars" resist easy translation into passwords? What if they run counter to justifications implied by a name—a name that can be "written on my card" and handed down, "[for me] to carry on my shoulders through the street, no matter where I go" (Guillen)?

To think in such a context about how to reconcile grandfathers who belong to different social backgrounds and racial classifications is problematic enough. Small wonder, then, that *A Tough Tale* is prompted to observe that we really cannot be displayed like "spotless whiteshirts" when we are in a time of road, dust, and heat; of rain, wind, and "stubborn night" (Serote 1987:7).

Now, while these questions are all disturbing, apartheid or separatist sensibilities make matters even more awkward when identity rubs against the ties that bind us sexually— when the "particulars" include the question of how it came about that there is a white grandfather and a black one.

"Pass" words and family cards* now need to engage the thorny issue of how much intimacy to highlight or conceal. At once voyeuristic and anxiety-ridden, sexual relations can produce "situations" that are very photograph-able. In this regard the policeman-photographer in Athol Fugard, *et. al.'s Statements After an Arrest Under the Immorality Act* is especially aware of the probative value of these scenarios: "I saw [white woman] Joubert and [black man] Philander lying side by side on blanket on the floor. She was naked and he appeared to be wearing a vest. Sergeant Smit started to take photographs." Given the occasion,

a sequence of camera flashes in the darkness exposes the man and the woman tearing apart from their embrace; the man scrambling for his trousers, finding them, and trying to put them on; the woman naked, crawling around on the floor, looking for the man. (96)

*card = photograph

Various particulars about this sort of "scrambling" are often on display in the South Africa of a J. M. Coetzee (*Waiting for the Barbarians, Foe,* and *Disgrace*) and the Nadine Gordimer of, say, *July's People* and *The Burgher's Daughter*. Elsewhere, they are embedded in the puzzled ironies and the sustained briefing for a descent into hell that we get in Bessie Head's *A Question of Power*. " If you're not careful you'll get insane just like your mother. Your mother was a white woman. They had to lock her up, as she was having a child by the stable boy, who was a native." (1974:16)

Now, in the Daniel Defoe original *Robinson Crusoe* (out of which Coetzee crafted his *Foe*), the white *man* in the tropics is haunted by the unauthorized appearance of a male "Apparition." The sheer illegitimacy of this apparition at first causes Crusoe to stand "like one Thunderstruck,...surpriz'd with the Print of a Man's naked Foot on the Shore" (1975:121). Notwithstanding, Crusoe is soon able to make things be what they should be— translating the shadowy apparition into a companionable shadow. First, he lets the native chap know that his name should be "Friday"—after all, he had found him on a Friday—and then, "I likewise taught him to say Master, and then let him know, that was to be my Name; I likewise taught him to say, YES, and NO, and to know the Meaning of them" (161).

Not quite so parenthetically, there is an apt extension of the same kind of sensibility and relationship in the 1977 J.D. Bold's *Fanagalo Phrase Book, Grammar and Dictionary, the Lingua Franca of Southern Africa* which directs white South Africans to practice saying "Wena azi lo golof? Mina hayifuna lo mampara mfan" ("Have you caddied before? I don't want a useless boy"). Among other things, this fanagalo (that is, kitchen kaffir) phrase book aims at ensuring a caddy with sufficient competence to eliminate the need for the phrase "Susa lo-mtunzi gawena. Hayikona shukumisa lo saka," that is, "Move your shadow. Don't rattle the bag." (Leylyveld 1985).

Scrambling the story line in *Robinson Crusoe* and the *Phrase Book* produces, in Coetzee's *Foe*, a South African narrative about a white woman who is ambiguously shadowed by Man Friday, though she does not appear to be unduly rattled by his nearness. As a result, what we get is a composite Mrs.[Robinson Crusoe De] Foe: This is a woman who is at once possessive ("my shadow") and darkly agnostic, or else coyly celibate, about what happens when identity comes with (or through) sexual particulars.

Of course, coyness is not quite the issue in Coetzee's *Waiting for the Barbarians* (1980). *Waiting* stalks its victims into a crucial insight, that the experience of being shadowed can make for thrilling hysteria. The narrative insists on this, and stakes its claim for this insistence on the premise that no woman can live along the frontiers of such sensibilities and not dream of "a dark barbarian hand coming from under the bed to grip her ankle"; that there is no man who has not "frightened himself with visions of the barbarians carousing in his home, breaking the plates, setting fire to the curtains, raping his daughters" (1980:8).

Conclusion, or, "Me and my Shadow,/ Walking Down the Avenue"

So I said to them: "Listen, if you guys want to do this your way, you have got to handcuff me and bind my feet together. So that I can't respond. If you allow me to respond, I'm certainly going to respond. And I'm afraid you may have to kill me in the process even if it's not your intention."
Steve Biko, *I Write What I Like*

Now, there may be avenues that are indeed wide and shaded in ways that allow for casual promenade. However, this assumes that one's identity blues can be kept at bay, and this is something that the song ("Me and my Shadow, / All alone and feeling blue") does not quite promise. The blues do indeed shadow the question that Serote asks in *Third World Express/Come and Hope with Me:* "if life is so simple / why can't it be lived / if it is so brief / why can't we let it be lived..." (1997:11)

Steve Biko's life and death dramatize just how narrow the margins are within which, whether old or new, the Republic of South Africa has been handcuffed/coupled to its identity crises. It is now obvious from Biko's *I Write What I Like* that the people of South Africa couple and decouple in ways that were as prophetic then (1978) as they are instructive today.

His "I'm afraid you may have to kill me, [even] if that is not your intention" maps a familiar geography of bondage and bonding. The effects echo in title after title from South Africa. They are constrained in *a question of power* (Bessie Head) and *the rhythms of violence* (Lewis Nkosi) upon which an Alan Paton pivots his *Ah, But Your Country is Beautiful* (1981) and Sipho Sepamla his *Ride on the Whirlwind*.

In this light, the ghostly township of Wally Serote's Alexandra is razed down as much as it raised up "like a thunder clap that froze in our hearts, ...above roars of a bulldozer" (1982:46). In all this, the ties that bind do so along a stubborn axis, between the studio and the funeral parlor.

As ever, *all* those involved risk being shadow, risk being turned into ghost. "That's us. Just ghosts, doomed to walk the night" This is how La Guma, in *A Walk in the Night* makes the point. Memory and consciousness are soon enough etched out in a graphic composite, as skeleton, shadow and ghost. The portrait that emerges is that of a "decayed ancient face with

purple veins, yellow teeth, and a slack mouth" (1986:28). This is the figure that staggers into our consciousness, with wine-stained hands that can and will leave big reddish marks behind them on the wall.

This representation is, it is true, disconcertingly spectral. Nonetheless, it haunts in ways that do not erase intimations of selfhood: "Bull," says La Guma's Michael Adonis as he takes another swallow at the bottle, and in the wretchedness of his designation as a "Colored" under apartheid, "Who's a blerry ghost?" There is in this statement the same spirit with which Serote devotes himself to the township Alexandra in a telling sequence of poems where he asks, "Alexandra, hell / What have you done to me?" (1982:46). He asks for explanation with good reason, understanding as he does the lesson Alexandra teaches so well: that "graves are not only below the earth / where worms are so well informed" (*ibid.*).

Granted, we may experience something akin to a "ride on the whirlwind" (Sepamla 1983) when we put places like Soweto and Alexandra and Sophiatown on display. Still, people do inhabit such places, and they can still laugh "a loud laughter [that will stretch] the ear from Soweto to Johannesburg to Pretoria" (*ibid.* 53). It is no surprise, then, as is true for both Sepamla and Serote, that disaffiliation is impossible, notwithstanding the lure of far places, and in spite of tongues which in their thirst only "tasted dust, / dust burdening [Alexandra's] nipples." The answer to the question of why affiliations remain stubbornly fixed is confoundingly simple (Serote 1982:25):

Alexandra, I love you;
I know
When all these worlds become funny to me
I silently waded back to you
And amid the rubble I lay,
Simple and black.

Because, even in the dark days of apartheid, (much less in the less-dark ones of the new South Africa), it was possible to believe that the "maddening laughter from the servants of the city" (Sepamla) could be transforming, even as "tears as big as eyes / fall to the ground" (Serote).

Now, it is true that there is hard evidence to justify putting the human condition on display in certain desperately unhappy ways. After all, "Since man is not holy to man, he could be tortured for his complexion, he could be misused, degraded and killed." The Elizabeth in Bessie Head's *A Question of Power* recognizes the image that is on exhibit here. However, it is precisely this recognition that makes her refusal to accept erasure all the more dramatic, even transfigurative.

Such is the extravagance with which, black and female, this protagonist proclaimed herself witness, exorcist, and prophet when she produced a revised version of that "dramatic statement" of Mohammed's. For what Mohammed had said was this: "There is only on one God and his name is Allah. And Mohammed is his prophet." What Elizabeth said was this: "There is only one God and his name is Man. And Elizabeth is his prophet." (Head 1974:206)

This parallels the urgency with which Wally Serote— though exhausted by testimonies about "bleeding through the ears and eyes" and "babies suffocating in suitcases"— "not pleading or praying, [but] just being polite " expresses "a wish to eye God," and to do so according to a different orthodoxy (1982:56).

References

Biko, Steve (1986). *I Write What I Like*.
 San Francisco: Harper & Row.
Coetzee, J.M. (1980). *Waiting for the
 Barbarians*. London: Secker and
 Warburg.
Coetzee, J.M. (1987). *Foe*. London:
 Penguin.
Fugard, Athol.(1986). *Statements*.
 New York: Theater Communications
 Group, Inc.
Gordimer, Nadine (1982). *July's People*.
 London: Penguin.
Head, Bessie (1983). *A Question of Power*.
 London: Heinemann.
Jeyifo, Biodun (1985), *The Truthful Lie,
 Essays in a Sociology of African
 Drama*. London: New Beacon Books.
La Guma, Alex (1979) *Time of the
 Butcherbird*. London: Heinemann.
La Guma, Alex (1968). *A Walk in the Night*.
 London: Heinemann
Paton, Alan (1981). *Ah, But Your Country
 is Beautiful*. London: Cape
Sepamla, Sipho (1986). *A Ride on the
 Whirlwind*. London: Heinemann.
Serote, Mongane (1989). *To Every Birth
 Its Blood*. London: Heinemann.
Serote, Wally (1987). *A Tough Tale.
 Banbury*. Oxfordshire: Klipton Books.
Serote, Wally (1997). *Third World/ Press
 Come and Hope with Me*. Cape Town:
 David Philip Publishers.
Serote, Wally (1982). *Selected Poems*.
 Parklands, South Africa: AD. Donker.
Singer, Isaac Bashevis (1996). *The
 Collected Stories*. New York:
 Noonday Press.

Lemuel Johnson

Lemuel Johnson, from Sierra Leone, is a
writer, poet, and scholar in African and
Comparative Literatures. His critical and
poetical writings include *Shakespeare in
Africa and Other Venues* (1998); *The Sierra
Leone Trilogy* (1995); "*A-beng: recalling
the Body into Question, in Out of the
Kumbla, Caribbean Women and Literature*
(1990), as well as translations of Spanish
poetry, in *Erotique Noir/Black Erotics*
(1992). His most current work is *Private
Parts and Public Bodies: The Experience
of Sexuality in African Literature*.

There had been a silence, as always happened at about the same time,

a long silence when none of them moved except maybe to lift up a glass and hold it high over their heads for the

dregs to drip into their open mouths, or to yawn and stretch and then slump back into their chairs,

 when one of them might scratch himself,

 another consider the voice of the woman in the backyard, the old woman who was scolding,

 rattling her words like stones in a tin,

 and all of them in their own time looking at the street outside, and the shadows,

 wondering if they were not yet long enough.

 It was not a deliberate silence;

 there was no reason for it, being at first just the pause

 between something said and the next remark,

 but growing from that because they were suddenly

 all without

 any more words.

Athol Fugard from *Tsotsi*

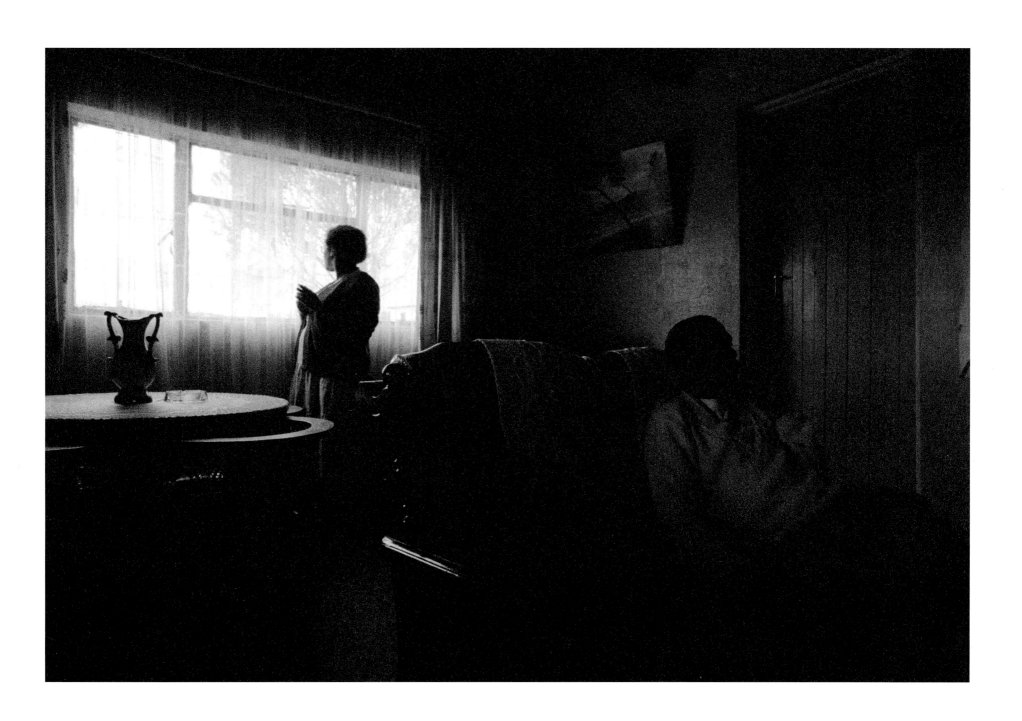

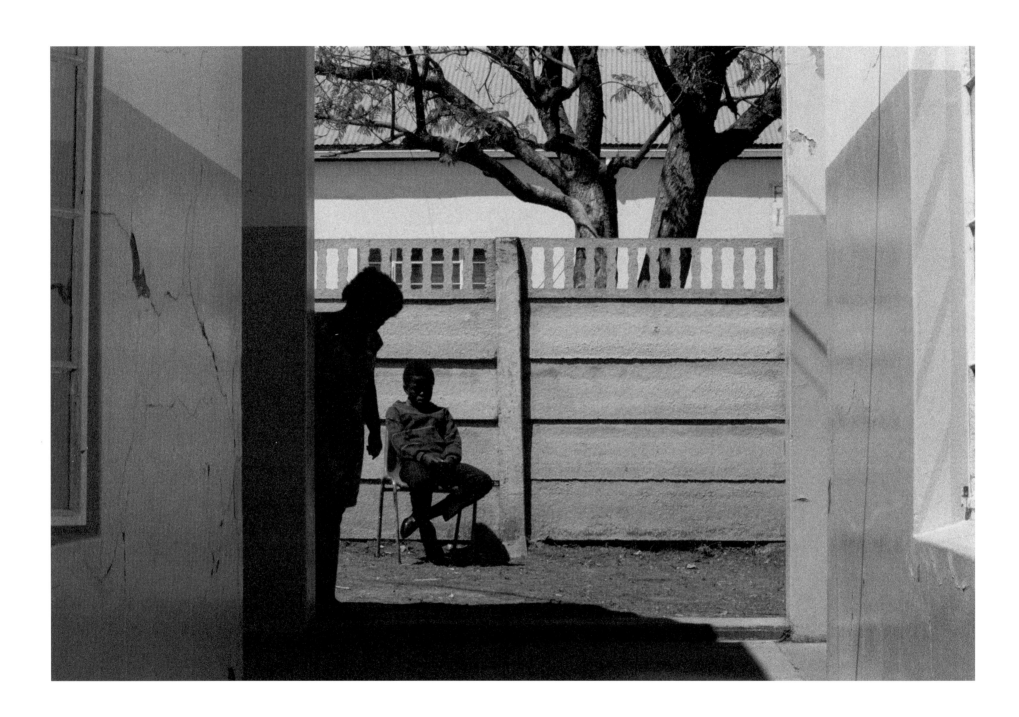

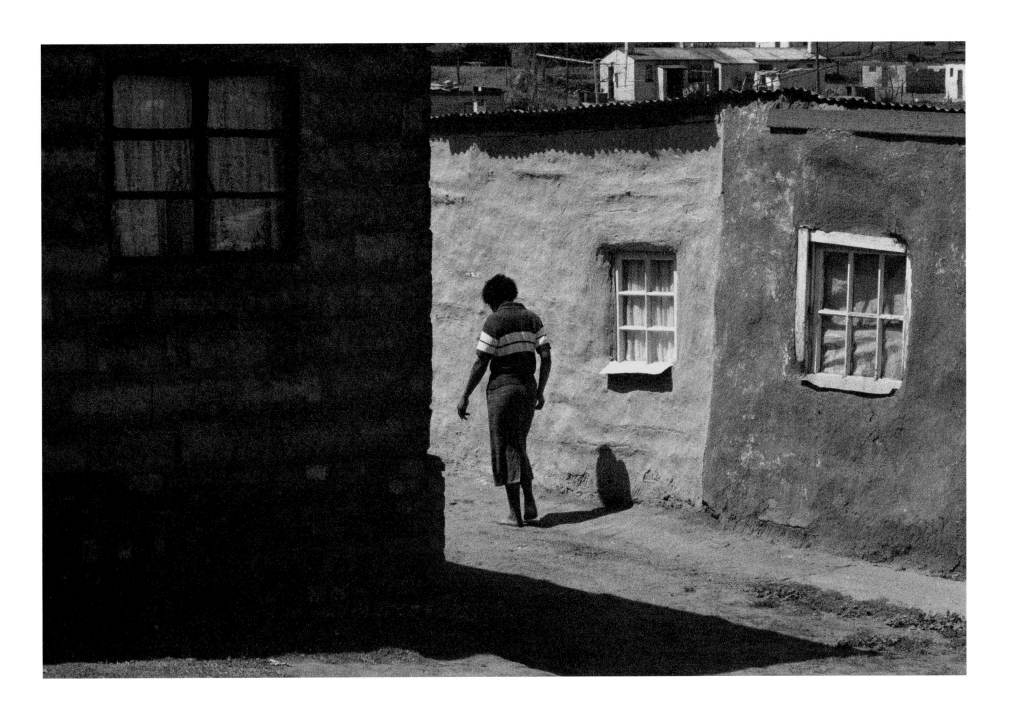

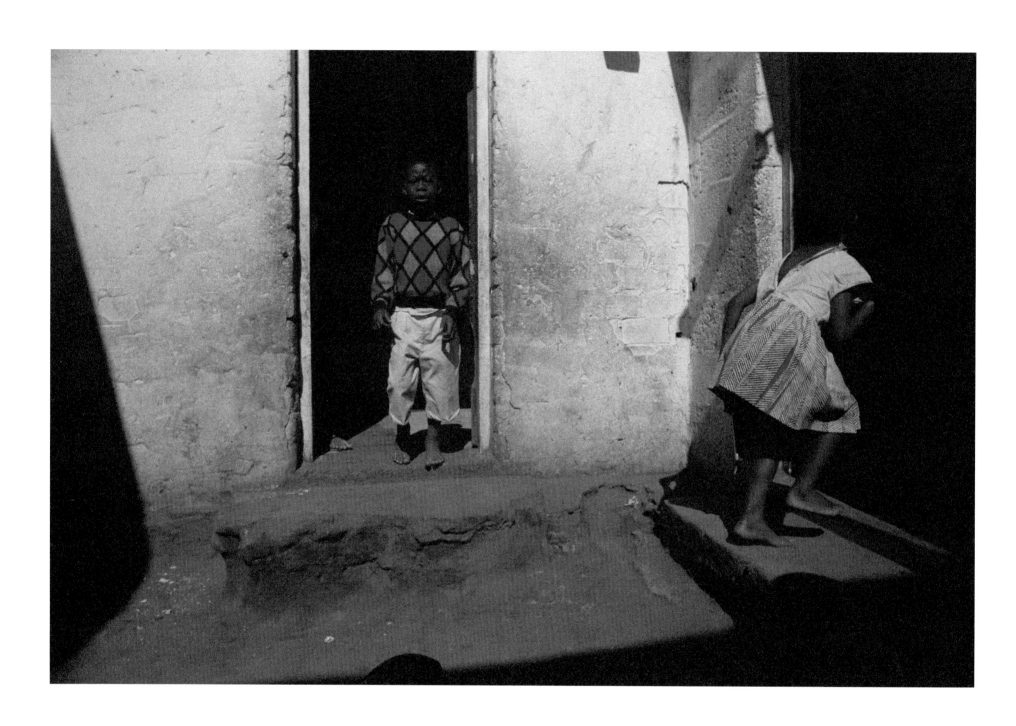

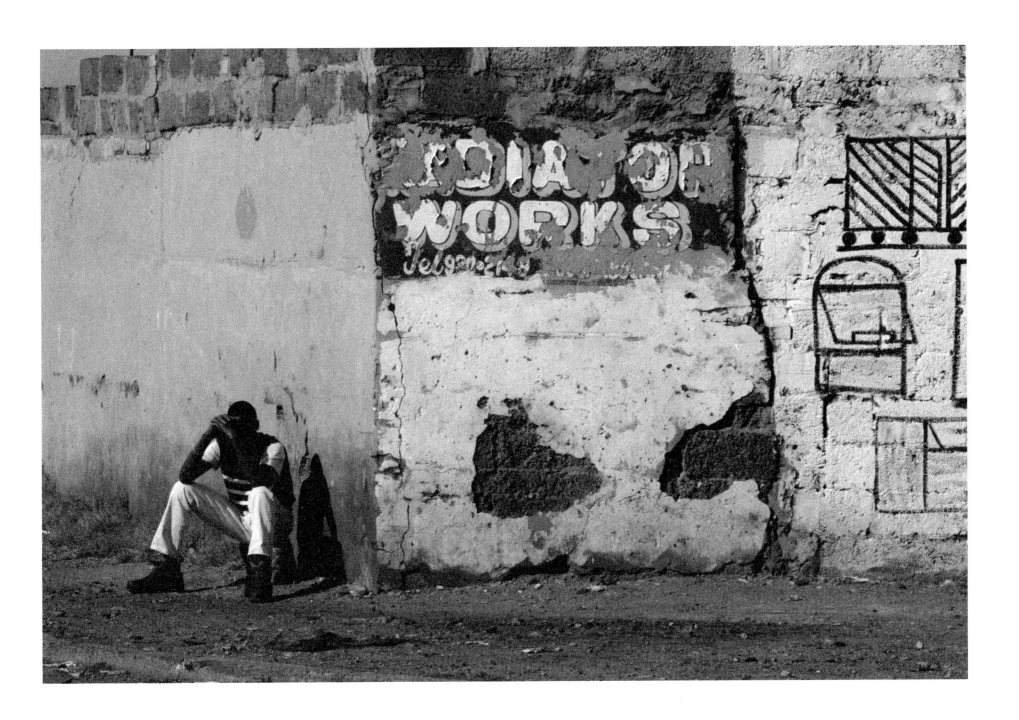

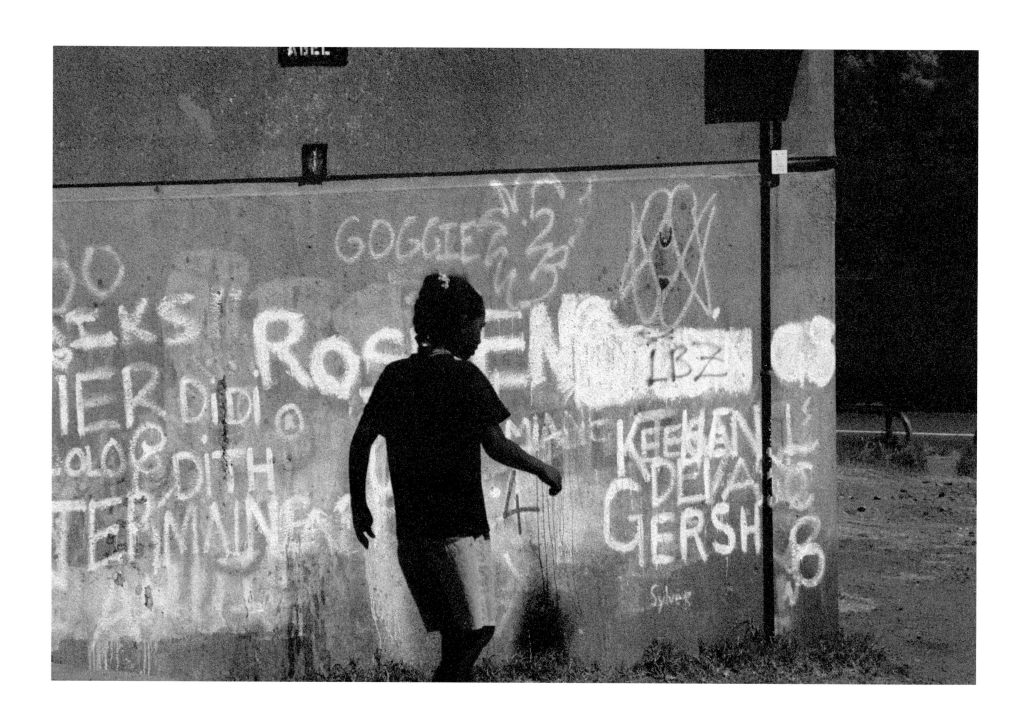

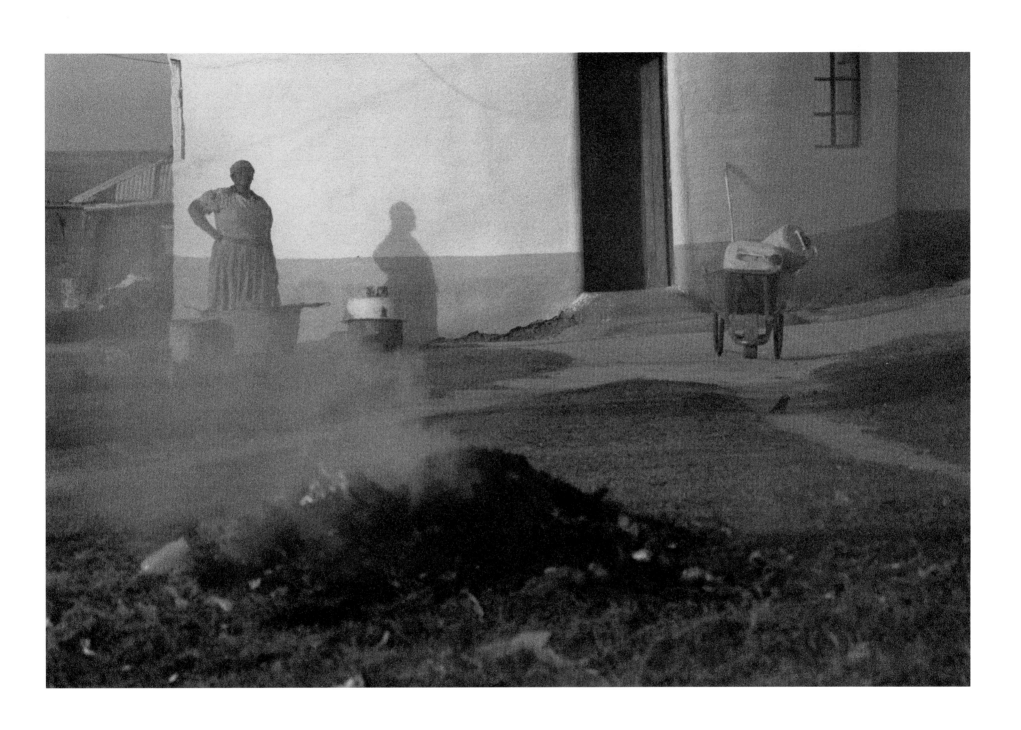

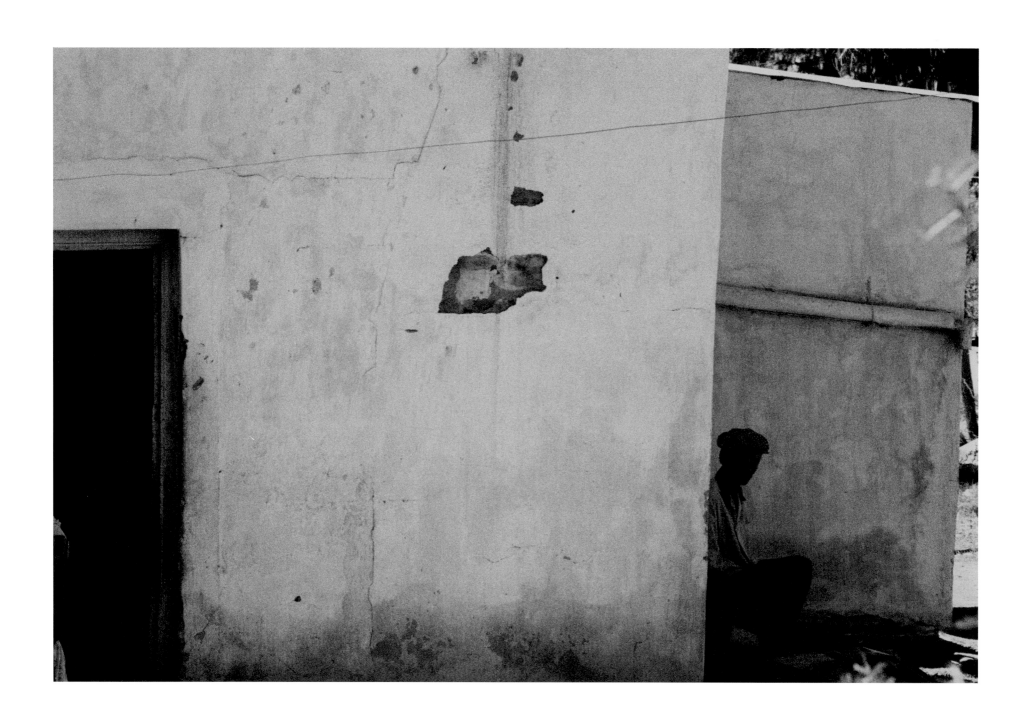

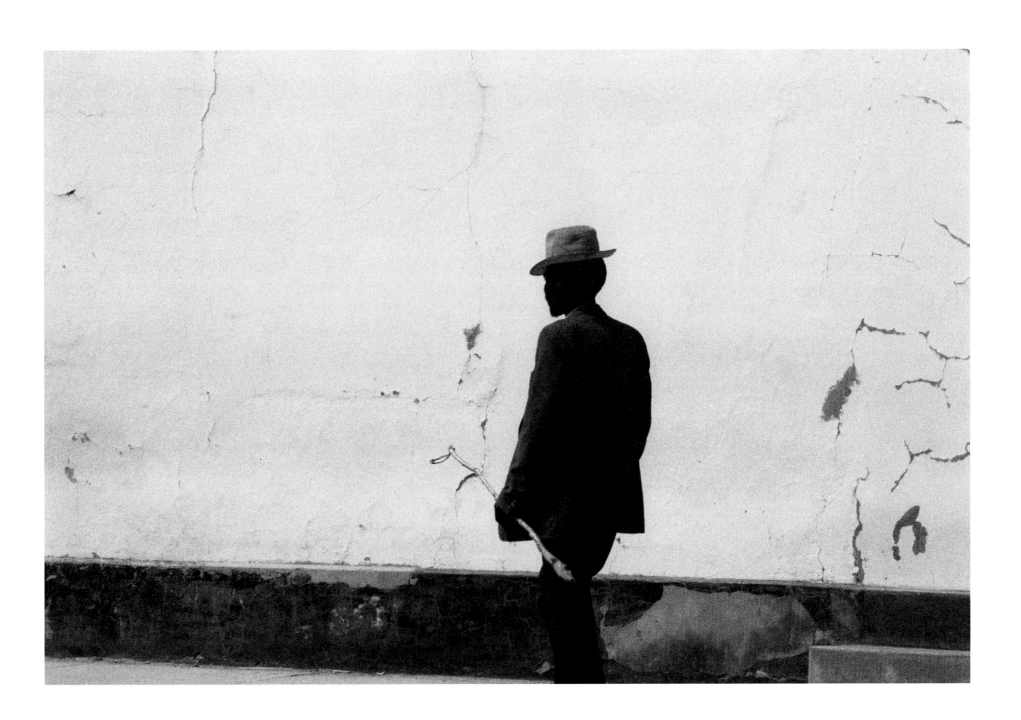

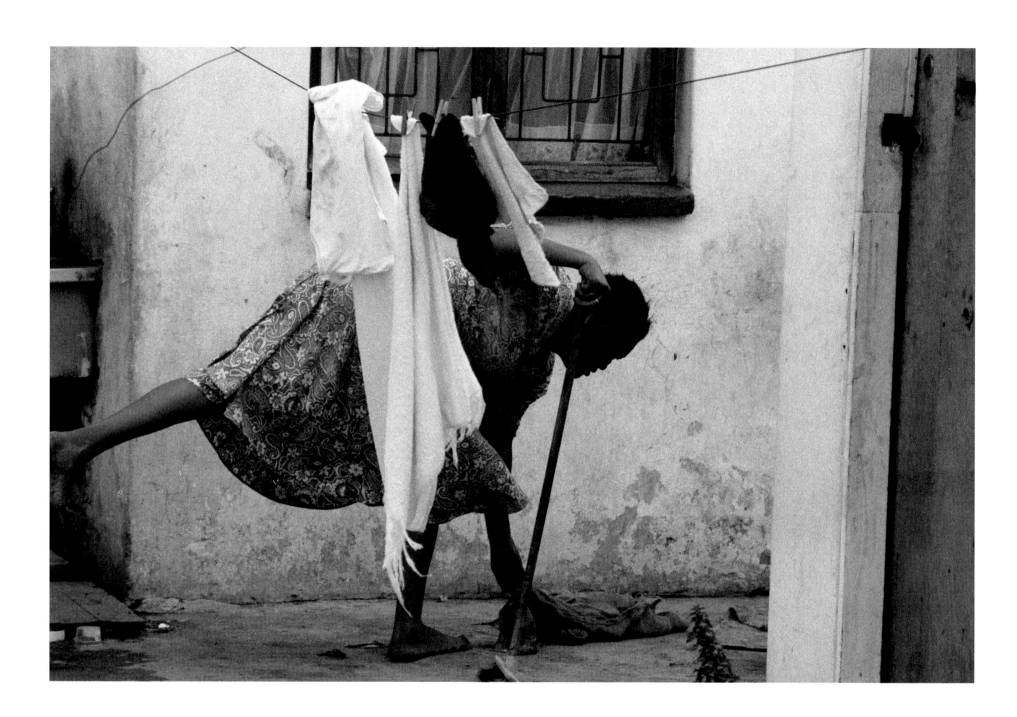

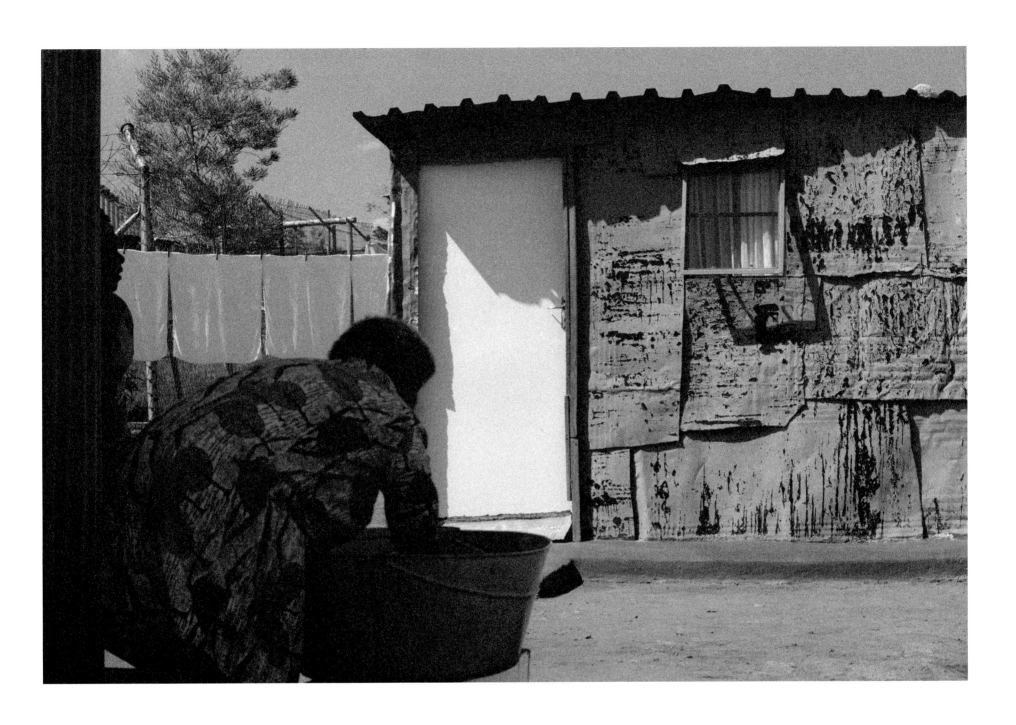

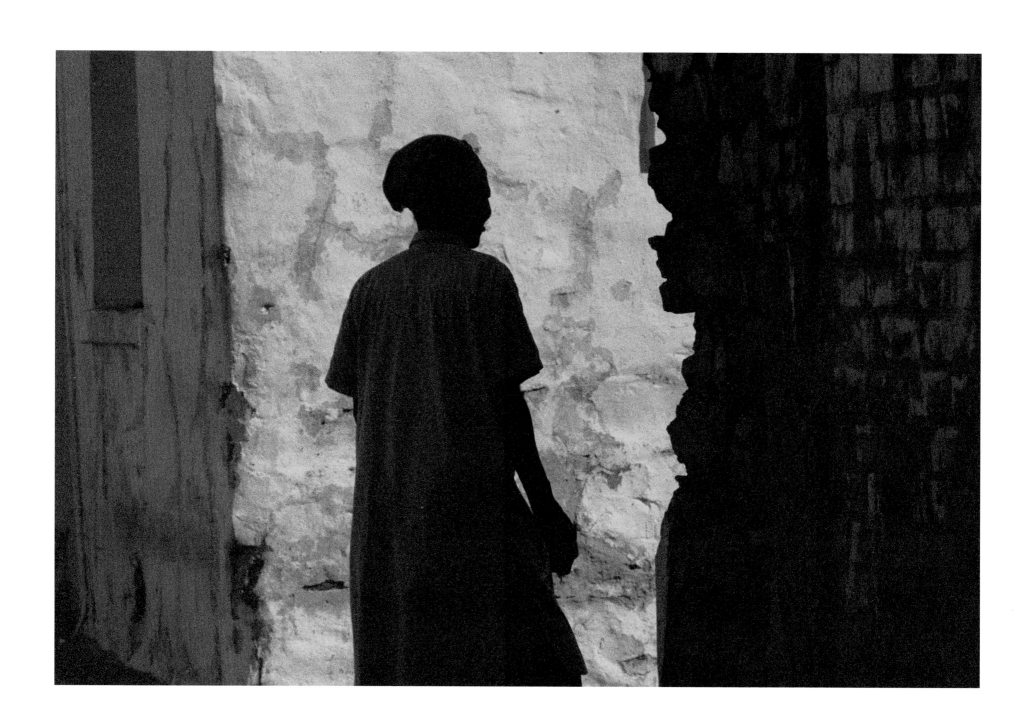

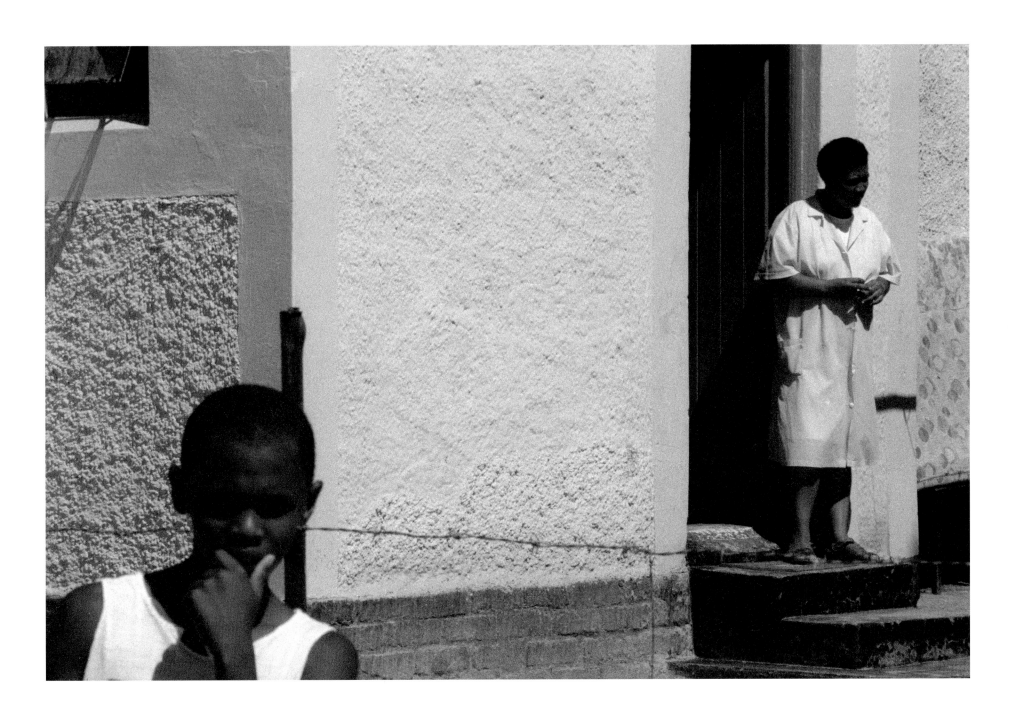

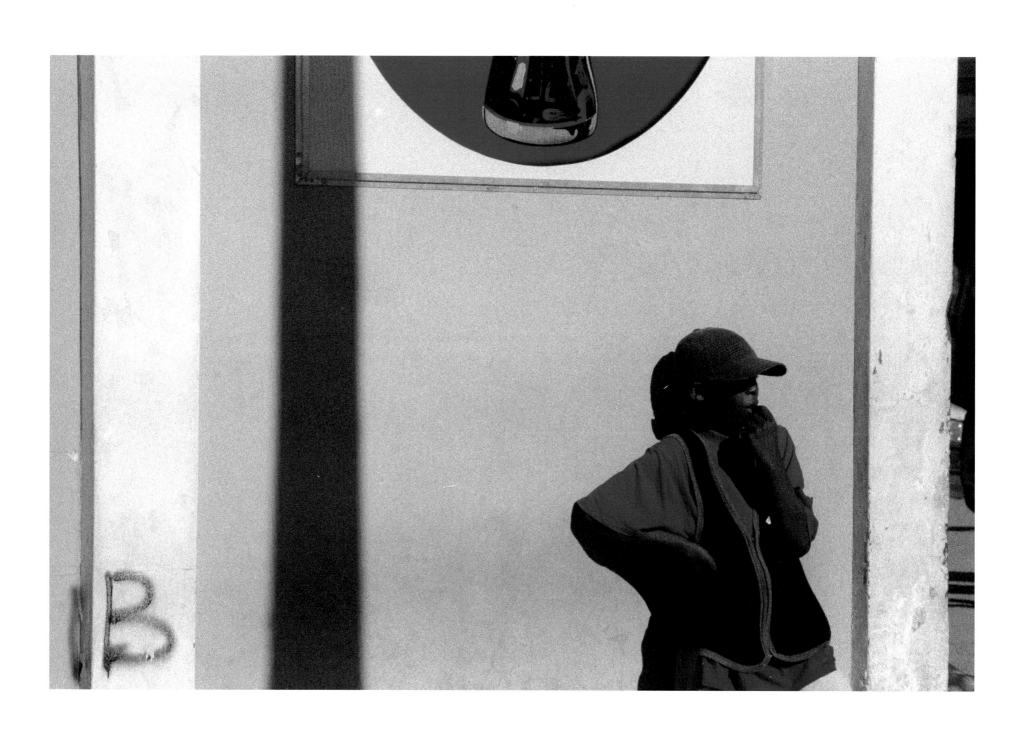

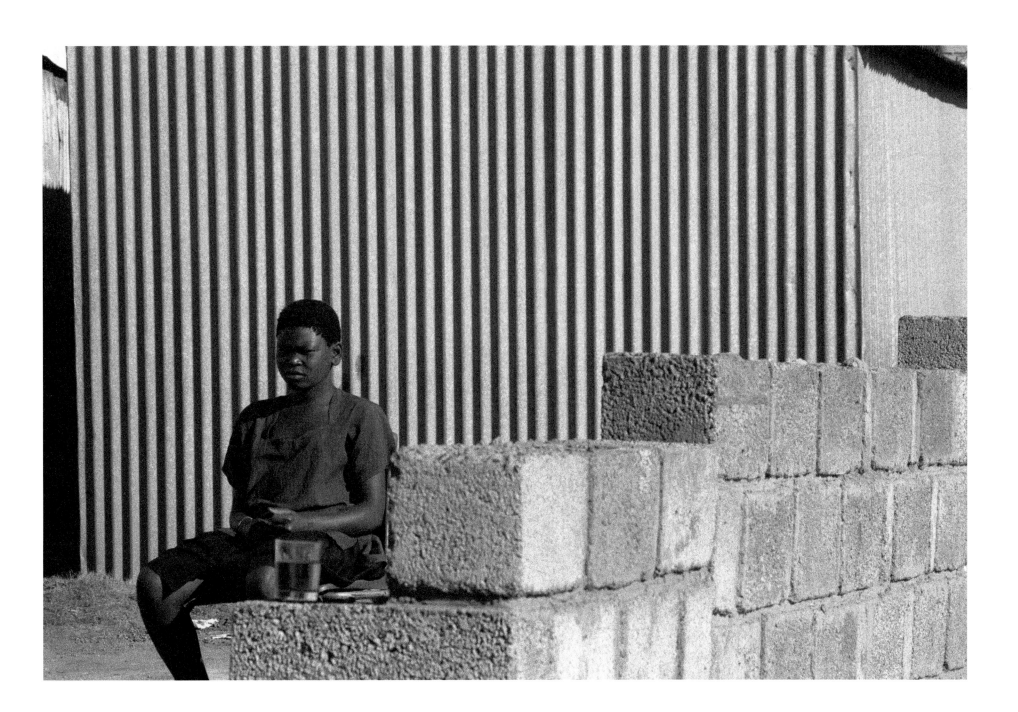

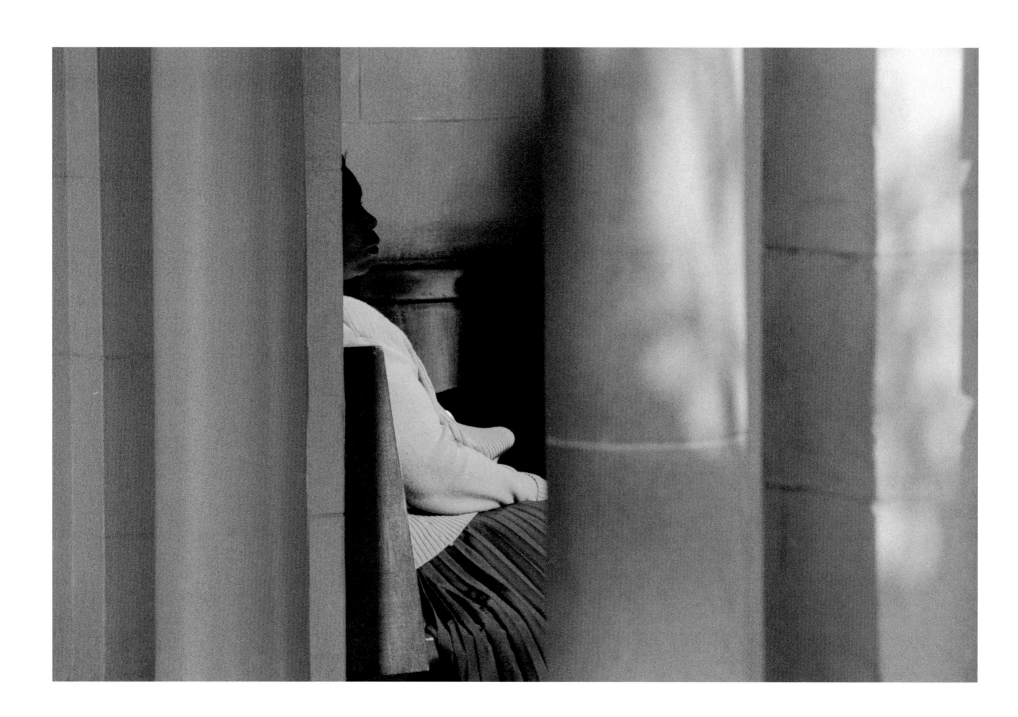

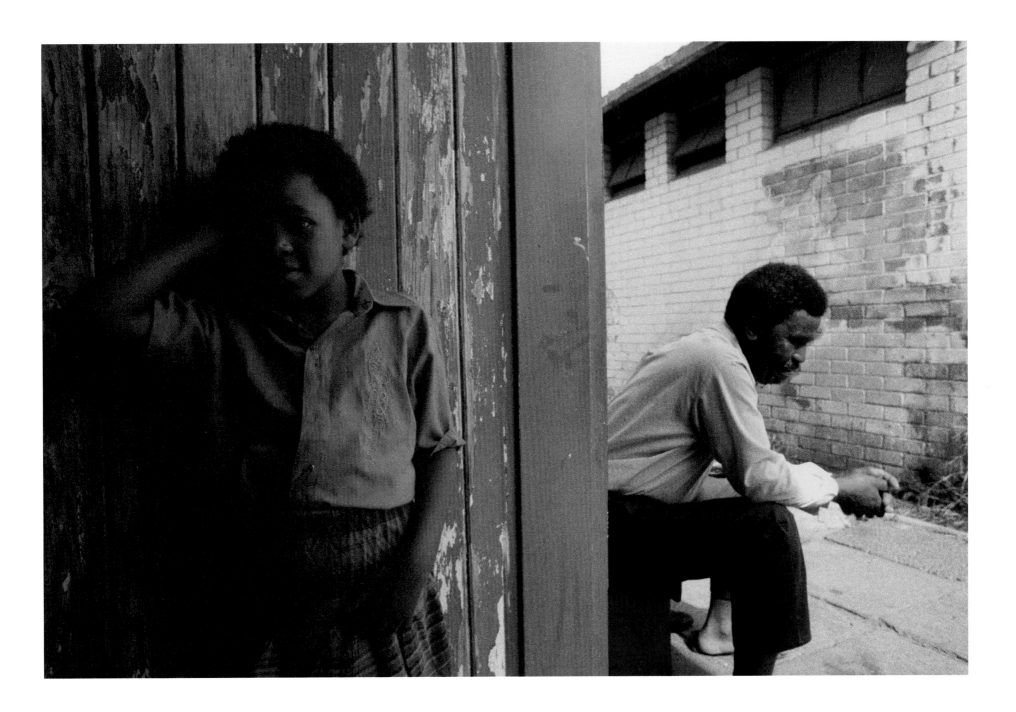

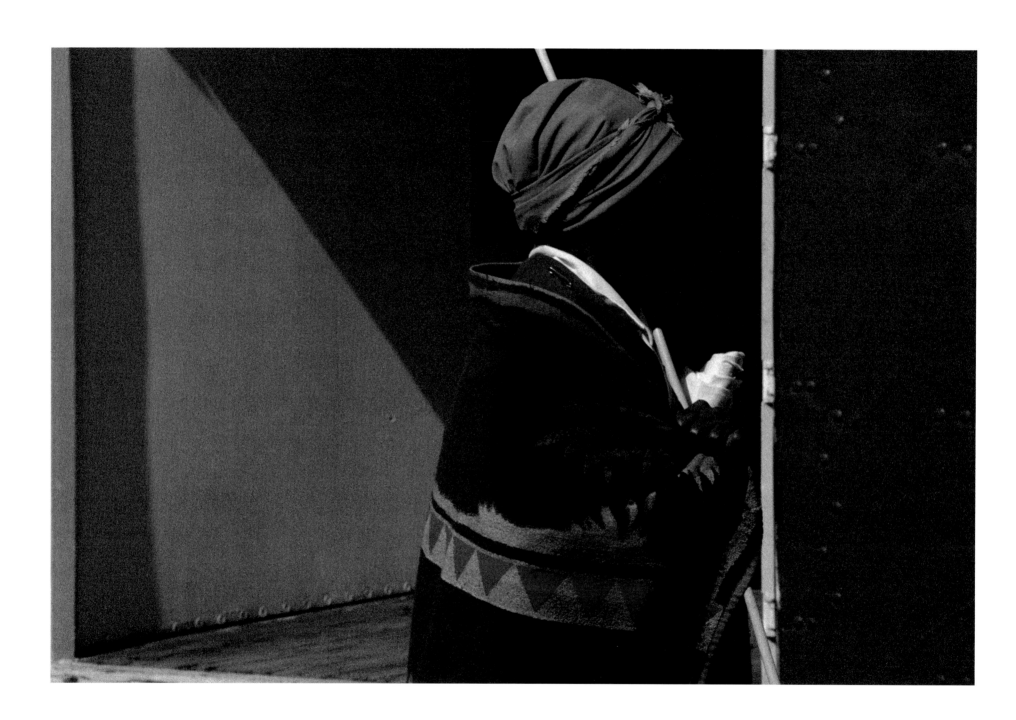

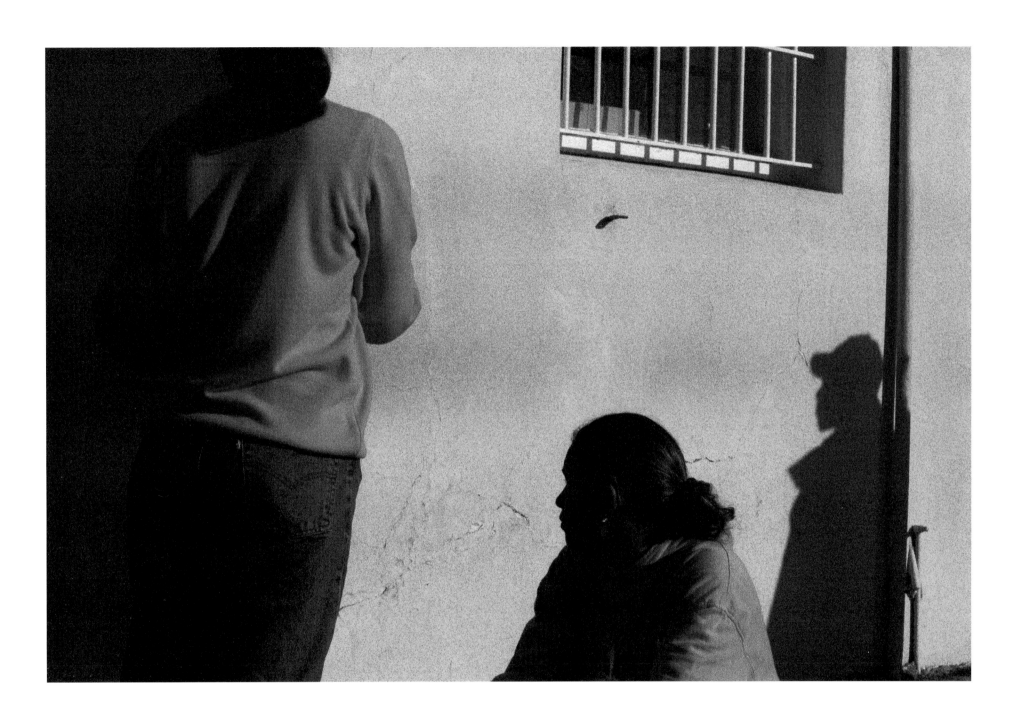

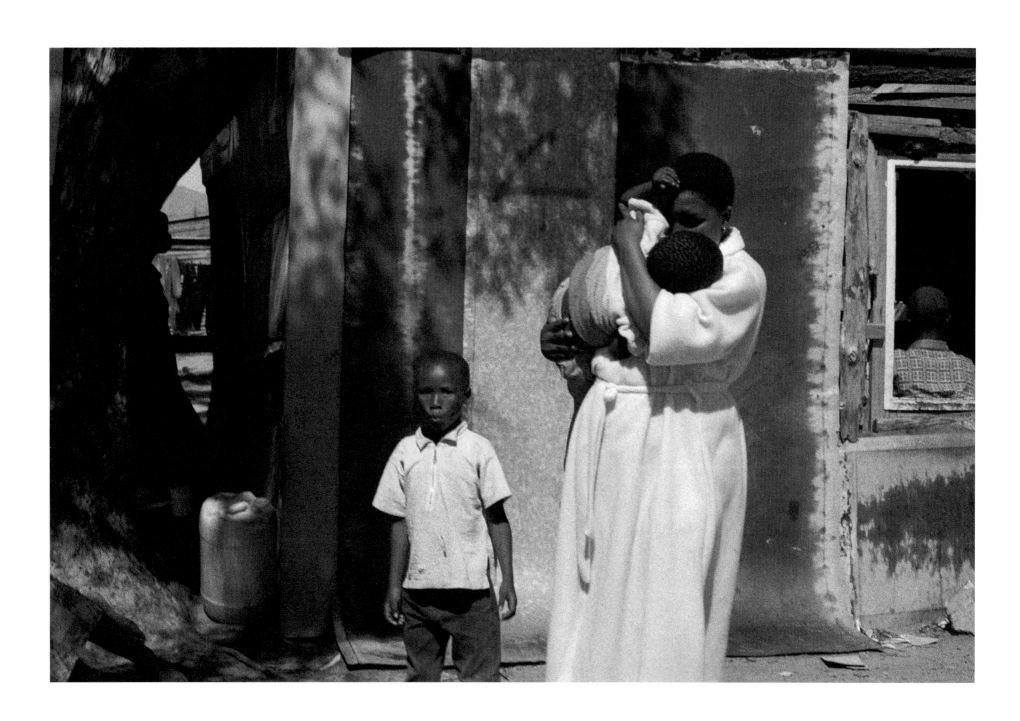

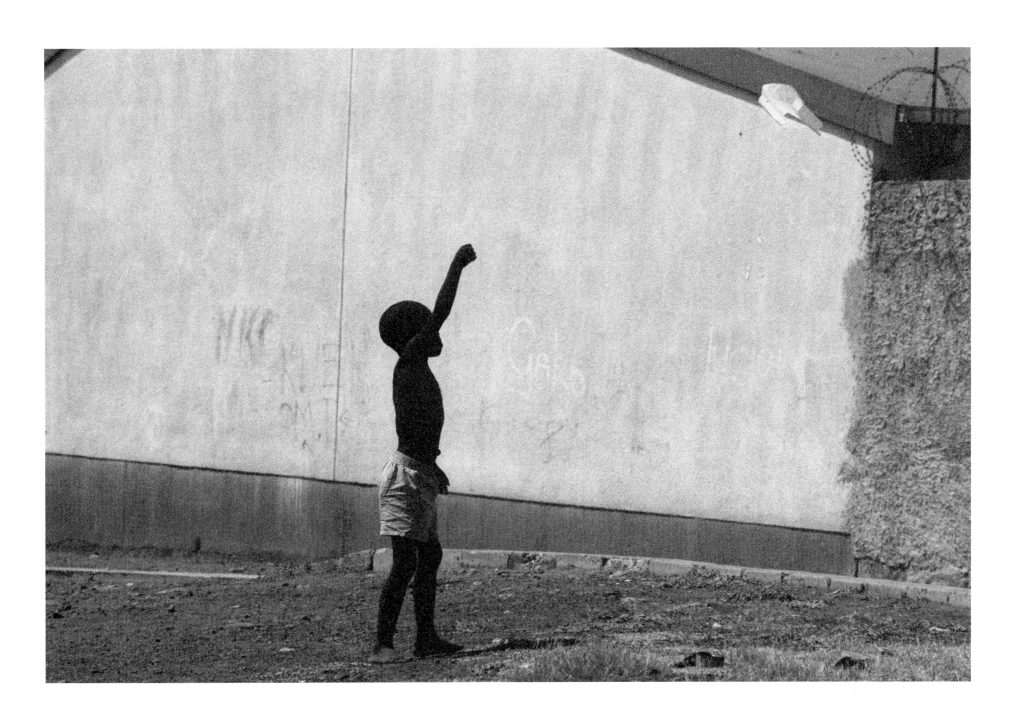

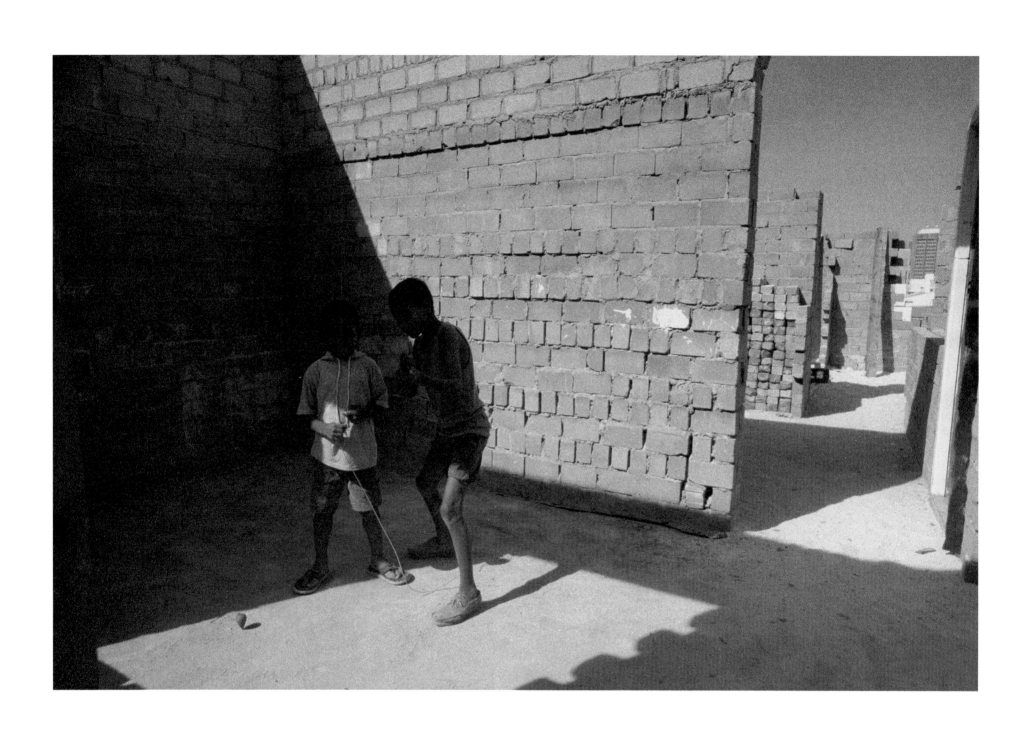

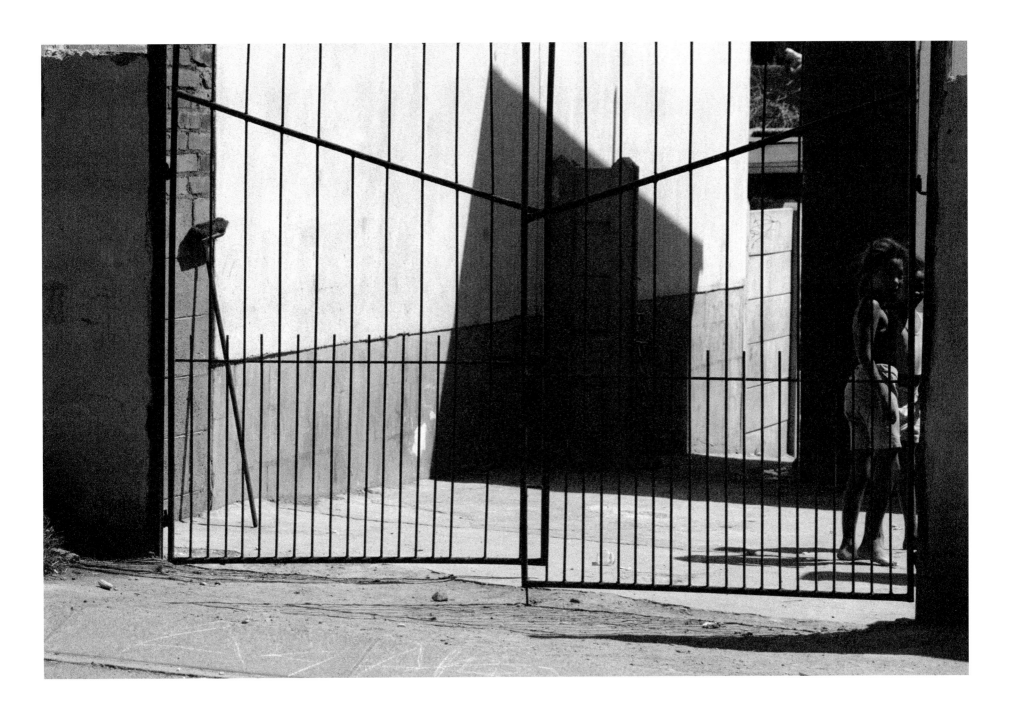

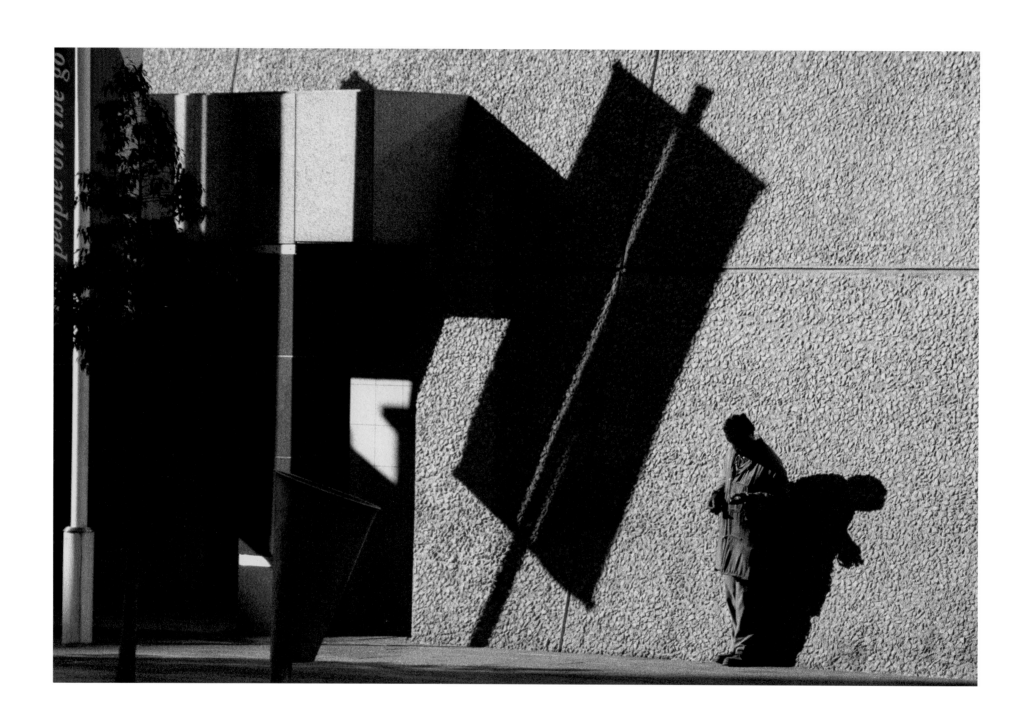

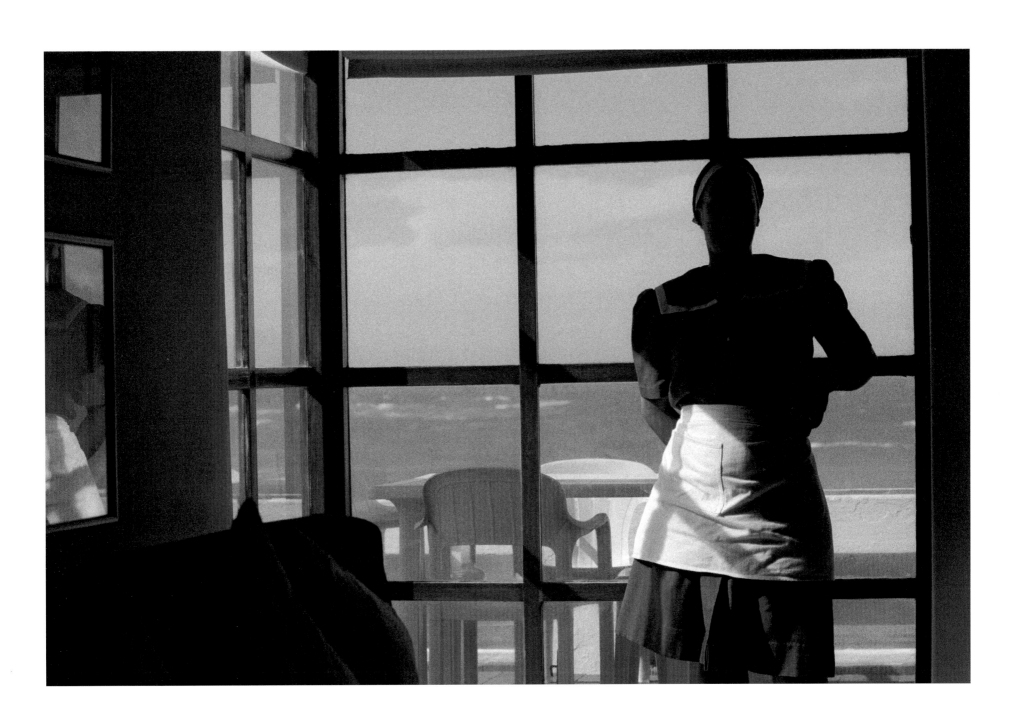

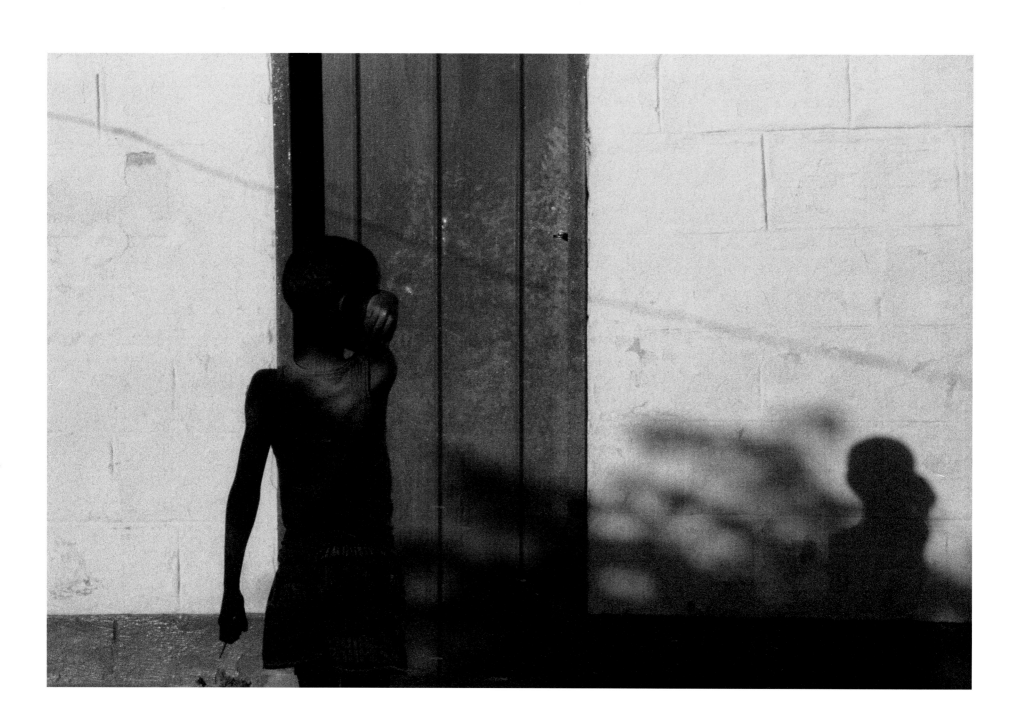

—— **Bendinephupho**

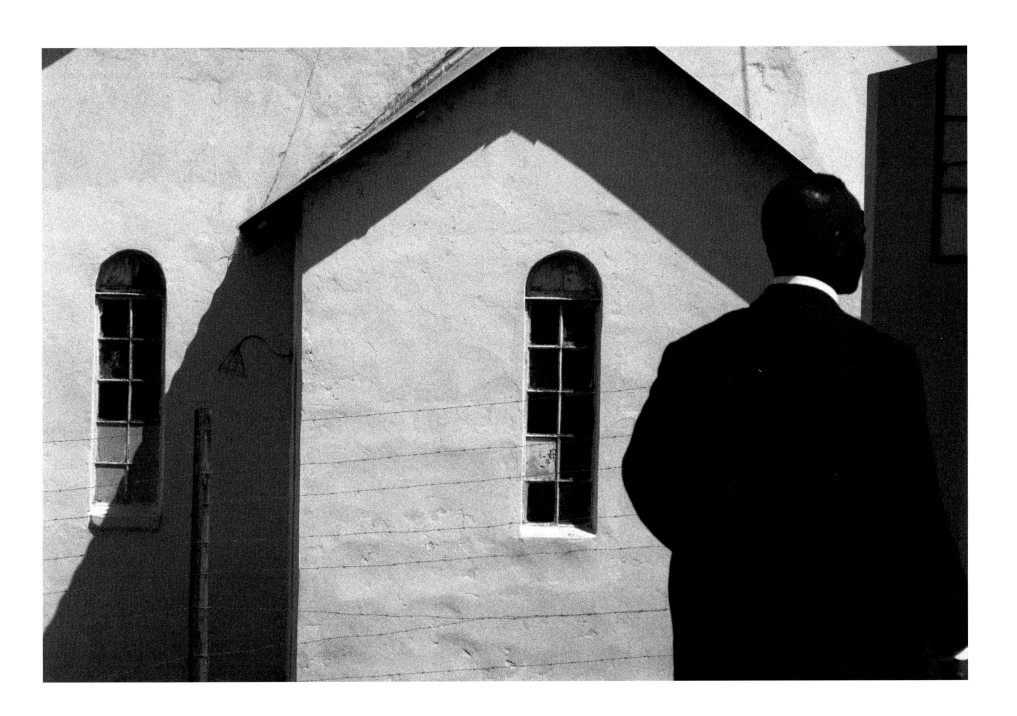

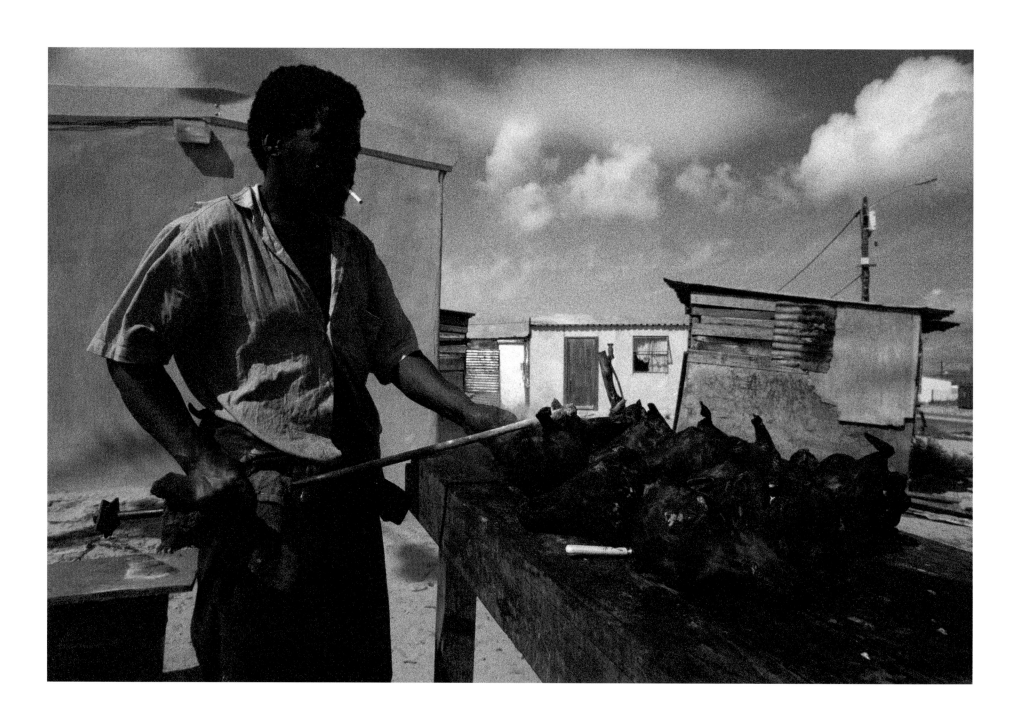

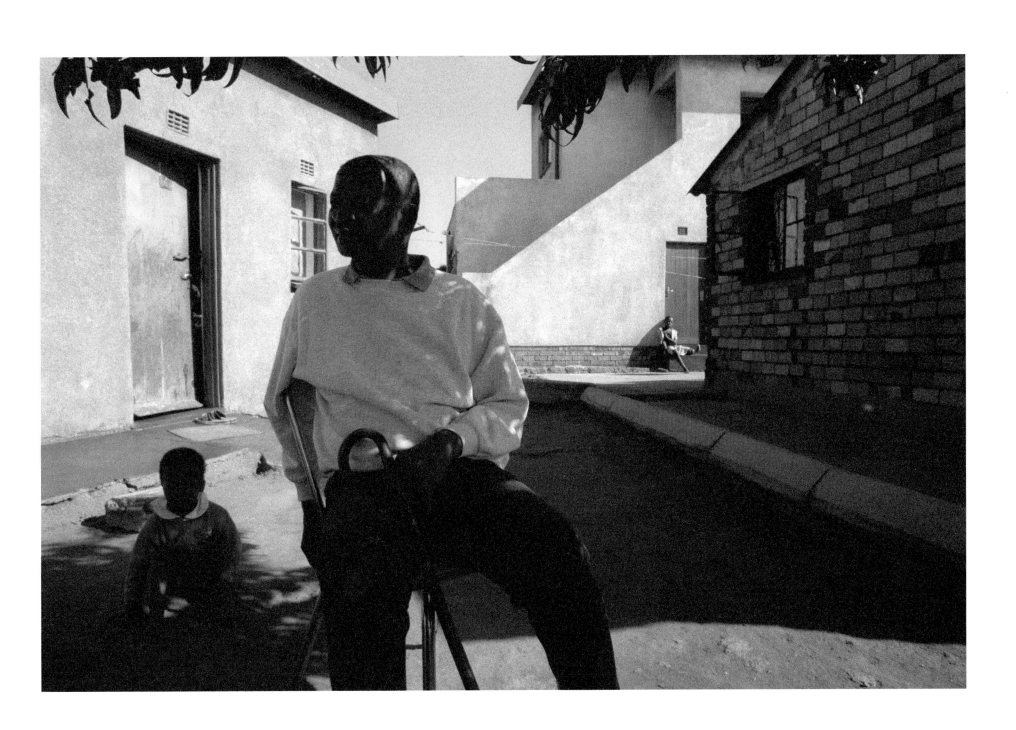

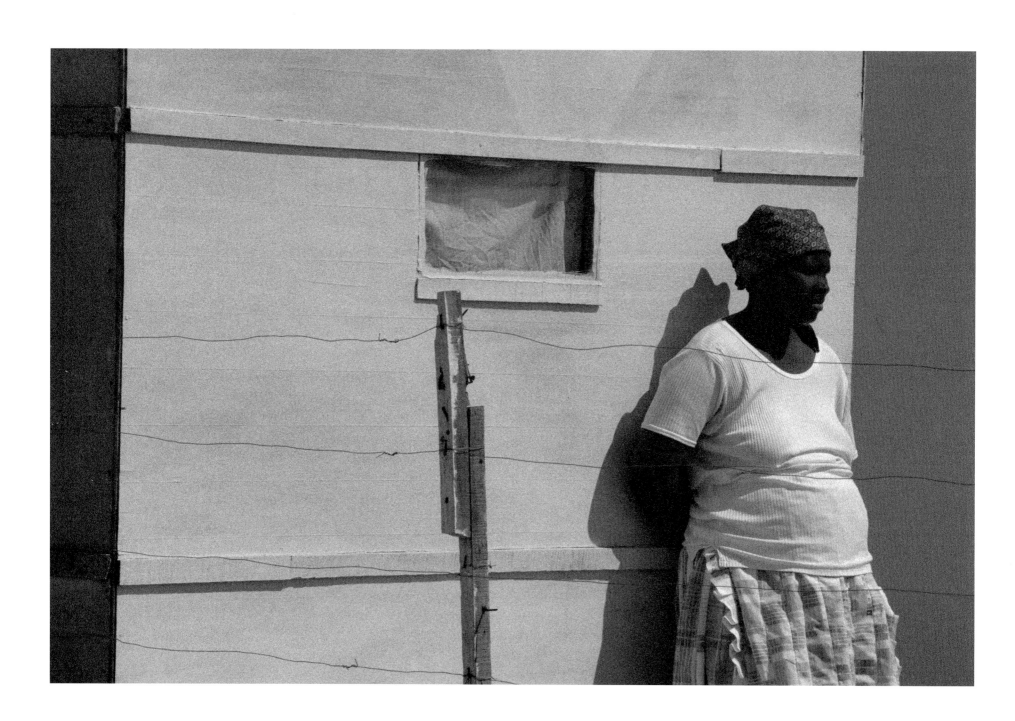

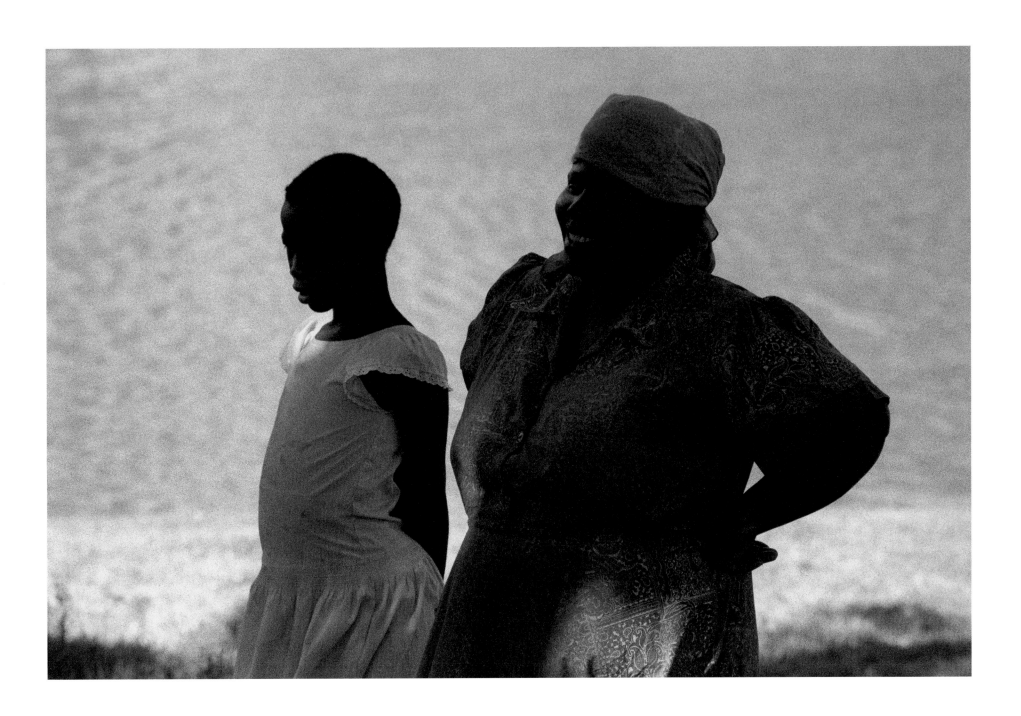

Someone is humming.
It is a deep,
undulating note,
pitched so low that it could be the murmur of men around a fire,
except that
occasionally a word breaks through the surface of sound
and then
it is heard to be a woman.
The soft, unfaltering tones
enfold the listening child in the
warm security of the one thought:
Mother.

Another voice, that of a much older woman,

calls out: 'Someone is happy',

and the first one breaks off her song to say,

'Yes Mama'.

The words are rising in ripples of laughter

which pass effortlessly into the song again

so that you could not say where the one ended

and the other began.

Emboldened by the admission, she sings louder,

phrasing the actual words at moments when they touch her happiness: '...

after time, a long time...

a lonely time...a shadow on the road...

and the cattle lowing at sunset...'

Athol Fugard from *Tsotsi*

Athol Fugard

South African-born playwright, actor
and director Athol Fugard is recognized
as one of the world's leading theatre
artists of whom the *New Yorker* has said,
"A rare playwright, who could be a
primary candidate for either the Nobel
Prize in Literature or the Nobel Peace
Prize." Fugard's major works include,
*Blood Knot, a Lesson From Aloes, Sizwe
Bansi is Dead, Boesman and Lena,
"Master Harold"... and the boys, the
Road to Mecca, My Children! My Africa!,
Valley Song,* and *Cousins: A Memoir.*
His most recent work is the autobio-
graphical play, *The Captain's Tiger.*

Checklist

All works are 28"h x 42"w
Giclee prints on Lysonic paper.
All works are from 1997–2000.
Note: Titles are drawn from four
of South Africa's eleven official
languages—Xhosa, Zulu,
Afrikaans, and English.